DIGITAL PHOTOGRAPHY EXPERT

DIGITAL PHOTOGRAPHY EXPERT

MICHAEL FREEMAN

ILEX

First published in the United Kingdom in 2005 by

ILEX 3 St Andrews Place Lewes East Sussex BN7 1UP www.ilex-press.com

Text © 2005 The Ilex Press Limited Images © Michael Freeman

This book was conceived by

LEX Cambridge England

ILEX Editorial, Lewes: Publisher: Alastair Campbell Executive Publisher: Sophie Collins Creative Director: Peter Bridgewater Managing Editor: Tom Mugridge Editor: Adam Juniper Art Director: Tony Seddon Designer: Ginny Zeal Junior Designer: Jane Waterhouse

ILEX Research, Cambridge: Development Art Director: Graham Davis Technical Art Editor: Nicholas Rowland

Any copy of this book issued by the publisher as a paperback is sold subject to the condition that it shall not by way of trade or otherwise be lent, resold, hired out, or otherwise circulated without the publisher's prior consent in any form of binding or cover other than that in which it is published and without a similar condition including these words being imposed on a subsequent purchaser.

British Library Cataloguing-in-Publication Data A catalogue record for this book is available from the British Library

ISBN 1-904705-58-8

All rights reserved. No part of this publication may be reproduced or used in any form, or by any means - graphic, electronic, or mechanical, including photocopying, recording, or information storage-andretrieval systems - without the prior permission of the publisher.

Printed and bound in China

For more information on this title please visit: www.web-linked.com/pcoluk

ntroduction	6
Chapter 1: The Language of Colour	8
Colour theory, colour practice	10
Colour models	12
Primary hues	16
Saturation	20
Brightness	22
The colour of light	24
Colour temperature	26
The broken spectrum	28
The colour of objects	30
Red	32
Yellow	36
Blue	40
Green	44
Violet	48
Orange	50
Black	52
White	54
Grey	56
Case study: chromatic greys	58

Contents

60

Chapter 2: Working Digitally

Colour management	62
Colour space	64
Calibrating monitors	66
In-camera colour	68
Camera profiles	7C
A question of accuracy	72
Memory colours	74
Personal colours	76
Black point, white point	78
Colour and contrast	80
The subjective component	82
Printer profiling	84
Chapter 3: Real Life, Real Colours	86
Colour relationships	88

colour relationships	00
Optical colour effects	90
Harmony	96
Red and green	100
Orange and blue	102
Yellow and violet	104
Multicolour combinations	106
Colour Accent	110
Discord	112
Colour and sensation	114
Muted colours	116

Case study: brown	120
Case study: flesh tones	122
Iridescence and metallic colours	124
Case study: images in sequence	128
Chapter 4: Choosing and Using	130
Colour as the subject	132
A colour style	134
Rich and intense	136
Restrained and commonplace	138
Colour and place	140
Case study: New Mexico	142
Urban colours	146
The colours of still-life	148
Selective enhancement	150
Distressed colour	152
Case study: unreal colour	154
Glossary	156
Index	158
Acknowledgments	160

Introduction

Colour is a wonderful phenomenon. In images from paintings to photographs it can bring a pleasure that is experienced rather than considered, in much the same way as music. And colour in photography is now much closer to painting than ever before, not in the way it looks but in the huge amount of control that digital cameras and digital image editing give. Whether or not you choose to exercise this control, the tools for it are there, in the camera's menu and in whichever imageediting software you use on the computer. They make it all the more important to have a thorough understanding of what colour is and how it works, practically and creatively.

The richness and complexity of colour as a subject is very largely due to its existence in three different planes: physical, physiological and psychological. They are different but interlocking, so that to have a good grasp of colour and how to use it means understanding all three. First, colour has an objective reality in that it obeys the laws of physics, originally demonstrated by Isaac Newton by using a prism to split white light into the colour spectrum. Red, for example, has a precise, measurable wavelength. But colour becomes meaningful only when it is perceived, and that requires the eye-brain combination, beginning with the coloursensitive receptors in the retina. Thirdly, colour has many and varied associations, not at all well understood but which have attracted endlessly conflicting opinion. There is, for example, the

association of colour with temperature (red warms, blue cools); of colour with state of mind (as Van Gogh demonstrated in *The Yellow House*); of colour with status (purple for royalty and high office from Greek and Roman times), and many more, not all of them consistent or reliable. They vary across time and across culture, by society and individual. Separating all these strands of opinion and symbolism is impossible, and yet they affect the ways in which colour is perceived.

The essential problem in digital photography is how to balance choice and colour judgment on the one hand, with process on the other. Process, which includes everything from in-camera settings, through colour management, to image editing and printing, is now a major component, yet the basic decisions of enjoying and selecting colour still rest in the eye. Being able to do anything with the colours of an image is a great new opportunity, but it remains the second step after colour discrimination. This book is an exploration of its nuances as they appear in front of the camera and as they can be made to appear in the final image, in print or on screen. There are a number of different approaches to this, from getting the colour right to altering it to suit your taste. You could think about these possibilities in the same way as other digital imaging techniques - as being different positions on a scale of intervention in the image. By no means does digital colour manipulation imply lurid changes. Gentle control is more useful, and more difficult to achieve.

The Language of Colour

Particularly in this chapter - and I hope it won't be tedious - I'll be drawing on the experience of painters. There are two good reasons for this. One is that the history of thinking about colour has largely been in painting, and seldom in photography until recently. By contrast, the body of work and discussion in monochrome imagery - black and white - has been very strongly placed in photography, and this is the focus of the companion volume to this book, Digital Photography Expert: Black and White. The other reason is that digital photography has opened many doors in the imaging process and, with a new wealth of digital tools with which to choose and control colours in photographs, it is now legitimate and valuable to look at how the construction of colour has been thought and argued about over the centuries. Digital photographers can now enter this world and, while this might sound grandiose, it's an opportunity that does exist and yet is only just beginning to be exploited.

In other words, what might once have been of mainly academic interest, as a foundation preparation for art appreciation, is now highly practical. Two developments in digital photography will serve to illustrate the new ways of thinking about colour that have already easily entered photography: the colour circle and RGB. The colour circle as a way of displaying pure hues has a long history, going back in a meaningful sense to Isaac Newton, yet how many photographers ever considered it? Now, along with colour-space models, it is familiar to anyone using Photoshop. It even makes an appearance in most digital cameras – when you adjust the hue, as in fine-tuning the white balance, the units are in degrees, which is to say the 360 degrees of the colour circle. RGB is even more well-known, a well-integrated acronym that implies a general understanding of how colour photographs are engineered from three primaries. In the days of film, knowing that colour film worked on the same principle, with a tripack construction, was of little practical use. You couldn't take it apart and alter the three layers. Now, of course, you can.

With this knowledge in hand, it pays to revisit the colour spectrum through the eyes of the photographer. In this chapter we'll see not only the theories, both past and present, that tie all colours together, but look at the individual colours themselves. The visual power of red, the brilliance of yellow, or the coolness of blue all present different factors for consideration. Part of the equation here is the learned, psychological responses to colours. both overt and hidden. Green, for example, tends to have positive connotations - spring-like lush vegetation, growth, and even 'go' signs - while red can be a warning colour. The better you understand the symbolism, the better you'll be able to take advantage of it in your work. In turn, your photographs will be more pleasing to the eye and you'll be better able to decide how to approach the next step of the modern workflow, digital manipulation, which we'll explore in greater depth throughout the book.

Colour theory, colour practice

Our response to colours is complex, involving reactions at an emotional, subjective level to the physical facts of light at different wavelengths.

responses at different levels, including some that are not always possible to describe accurately. Nevertheless, the difficulty of finding an exact terminology does not lessen the importance of what Gauguin called the 'inner force' of colour. It is often more appropriate to say that we experience, rather than simply see, a colour.

The physicist James Clark Maxwell, in 1872, determined that the human eye distinguishes colour by responding to three different stimuli, the so-called tristimulus response that is very closely related to the way in which digital cameras and computer monitors work. He wrote: 'We are capable of feeling three different colour sensations. Light of different kinds excites these sensations in different proportions, and it is by the different combinations of these three primary sensations that all the varieties of visible colour are produced'. In fact, the three stimuli are three different pigments in the cones of the retina – erythrolabe, chlorolabe, and rhodopsin – which are sensitive to red, green and blue.

This discovery had major implications, not only for the recording and display of colour - digital sensors, film and computer monitors work using much the same principle as the eye - but on the fundamental idea that all colours can be created by mixing three. Painters had already come to that conclusion, though with different hues, and all this lent a special force to the concept of basic colours, the ones that can be used as building blocks to make others. Here is a case where physical fact transforms into colour aesthetics, and for much of this chapter we'll look at colour through its basic perceptual hues. The starting point is the palette of pure colours.

Most of the theory of colour asthetics has been developed with painters in mind, and for the most part has only vaguely been applied to photography. I shall attempt to redress this balance a little in the following pages. The usefulness of studying colour theory for a photographer is that it will refine

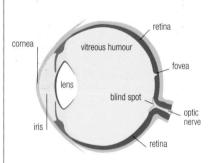

The eye and perception

The lens focuses an image, with the iris helping to control the amount of light entering, as in a camera lens. The retina contains a mixture of rods and cones, one sensitive to low light but monochrome, the other needing more light but sensitive to colour. The fovea has the highest concentration for high resolution.

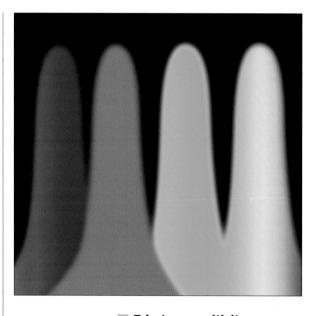

Tricolour sensitivity

Like a sensor, there are three types of cone, each sensitive to a different wavelength. Note that the red-sensitive cones actually peak in yellow. Scotopic, monochrome vision, peaks in between blue and green. These charts show the wavelength response of the green-sensitive cones, blue-sensitive cones, red-sensitive cones and scotopic vision (rods).

Adding the three kinds of cone together gives spectral vision that is clearly weighted toward green, but the addition of the rod sensitivity gives an even spread.

your discrimination and judgment. It is too easy to evaluate colours and colour relationships on the simple, subjective grounds of 'like' or 'don't like'. Certainly, most people do judge colour in this way, but this is analogous to enjoying music without having any musical training; while the lack does not inhibit the pleasure of listening, a study of music will definitely enhance it.

Moreover, if as a photographer you want to become skilled in creating powerful colour effects, the theory will give you the means. Although colour provokes a subjective response in a viewer, it does obey definite laws; as we will see in a few pages, when we consider relationships between colours, the principle of harmony is not only a matter of whether an effect seems pleasing, but also depends on the actual, physical relationships and can be measured.

The multi-level sensation of colour

Our ultimate response to colour depends on a mixture of the physical, physiological, and psychological components. Colour is wavelength and measurable scientifically (see page 24). It is then processed by the eye-brain combination, beginning with the retina. Finally, the brain relates this stimulus to its own experience, which can involve associations as varied as emotion, preference and symbolism.

Colour models

An essential first step in describing and dealing with colour is to measure it in a standard way. There are several of these methods, each with its particular uses and each using three parameters. This is part of a terminology that has sprung up with digital imaging, but in fact colour models evolved centuries ago. The first colour diagram known is from the 15th century, but it was a scale of the different colours of urine for medical use. The scientific analysis of colour and the creation of graphic models to represent it began in earnest after the publication of Isaac Newton's *Opticks* in 1702. His key discovery was that light contains

a sequence of wavelengths that each have a specific colour, which we will look at in more detail on page 24, but this has overshadowed two other

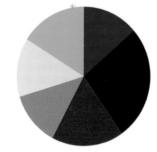

Newton's circle

The spectral colours identified by Newton are those of the rainbow and are commonly described by seven names: red, orange, yellow, green, blue, indigo and violet. All of these can be laid out in a continuous progressive sequence, but if this sequence is arranged as a circle, as Newton did, the relationships between all the hues become clearer. The circle is also a great help in understanding the reasons for colour harmony and balance. It is the basic tool of colour theory. Newton described the colours in his book, rather than showing them, and they have been interpreted here. With seven identified hues, it is, of course, asymmetrical.

The spectral circle

The colour spectrum is in fact continuous, one hue blending into the next. Here it is arranged as a circle and rotated so that red (0° in the usual notation of hues) is at the top.

The colour triangle of Delacroix

The French painter Delacroix constructed a triangle with arcs of primary colours at each apex, connected by the secondaries. important contributions. One was to arrange colours in a circle to show their relationships with each other, and that which followed from it: the notion of complementary colours, opposite each other on the circle, which mix to create a neutral. More of this in Chapter 3.

The earliest colour models were circles, though other shapes were used, such as the triangle and linear scales. For considering hues these twodimensional diagrams are adequate, but as the full range of colour needs three parameters, the more complete colour models are now usually represented as 3-D solids. As we will see in the next several pages, the most widely used and accepted set of parameters for defining colour are hue, saturation, and brightness.

Considering just the colour circle and hue - the essence of colour - there is a conflict between those models based on reflected light and those based

Blanc's colour star A colour star by Charles Blanc in 1867 uses

conventional primary and secondary colours, but the tertiaries have more than usually exotic names.

Ostwald's circle

The German chemist Wilhelm Ostwald in 1916 produced a 24-part circle based on the four perceptual primaries: red, yellow, blue and green. Edward Hering had argued, like Mondrian, that green was perceptually basic.

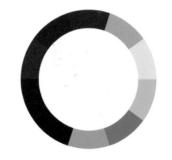

The Munsell circle

The American painter Albert Munsell published in 1905 his colour model that was to become the standard for colourimetry, and is used to this day (GretagMacbeth charts use his system). It is based on five principal colours – red, yellow, green, blue, and purple – and five intermediates, all finally sub-divided into 100. This circle was the basis of the more valuable solid (below).

Field's linear scale

In 1835, George Field, colour theorist and friend of the painter John Constable, produced this linear diagram of primaries, secondaries, and tertiaries, beginning with red, yellow, and blue. The triangles are divided into light and dark modulation. on transmitted light. We will keep returning to this issue, because it causes problems with identifying primary colours (page 16) and complementary relationships (pages 88). When Newton began the debate with his splitting of the prism and his colour circle, he was showing spectral colours, while most other colour theorists worked, quite reasonably enough, with pigments that are seen by reflected light. In digital photography we use both systems – transmitted light for viewing on the monitor and reflected light for prints – so we cannot escape the conflict. This is examined in more detail on the following pages but, basically, not only are the hues somewhat different between the two systems, but they are viewed in completely different

The Munsell tree

In Munsell's 3-D solid, chroma runs around the circumference, with a scale of desaturation inward toward the centre and a polar axis from black to white. But because maximum saturation (chroma) is reached at different levels of brightness by different hues, the final shape is asymmetrical and so often represented, as here, as a tree. Here, Munsell's steps have been replaced by continuous tone.

Itten's circle and triangle

The colour circle of Johannes Itten at the Bauhaus also begins with red, yellow, and blue. With the secondaries and tertiaries this divides into 12 parts. The colour triangle is derived from this, although the tertiaries are necessarily different.

📲 Itten's colour star

Seeking to represent the light-and-dark modulation of his colour circle, Itten devised this star-like projection of a sphere onto a flat surface. Pure hues are in the middle zone.

14

circumstances so that there is no common ground for comparing them. The spectral colour circle of Newton printed here is only an approximation, as it is impossible to reproduce accurately on paper with printing inks.

As colour models developed, they took into account the ways in which colours are modulated to be brighter or darker and to be more or less saturated. Painters could achieve all of this modulation with black and white pigments (or with complementaries), which is why it took some time to arrive at a full understanding of the three axes of colour - hue, saturation and brightness. Reproducing these made a three-dimensional solid necessary, and the first was that created by Albert Munsell.

+b (vellow) +120

a = 90b = 40

+a (red)

+120

hue h

L*a*b*

CIE Lab (strictly speaking, L*a*b*), was developed in 1976 by the Commission Internationale d'Eclairage. designed to match human perception as closely as possible. It uses hue, saturation, and brightness along three axes, and digitally these are three separate channels, which can be accessed in Photoshop. Significantly, it is a very large colour space, and so is a useful theoretical model that can contain most other models. One axis/channel is L* representing luminance (that is, brightness), a second is a* for a red-green scale, and the third b* for a blue-yellow scale. The principle is that red cannot contain green (nor vice versa) and blue cannot contain yellow (nor vice versa). Shown here are a circular cross-section and a cross-section through the 3-D solid. This latter cross-section represents the spectral colour gamut with a characteristically asymmetrical shape due to the human eye's extended sensitivity toward green. We will see this shape later when we look at colour spaces and gamuts (page 64).

Primary colours

Red, green, and blue are the primary colours of the digital age, while red, yellow, and blue mix to form most other shades for the painter (see sidebar page 18).

achromatic point

-a (green)

-80

Primary hues

A few pure hues are considered to be the basic colours, from which all others are derived, yet there have been different versions of exactly what these are. The idea of primary colours is an old one, dating back many centuries, but it has not always meant the same thing. In one sense it means a core of the most important colours, but added to this is the concept of irreducible hues from which all others can be created. These two are not necessarily the same. Most of us are now familiar with the idea of digital colour being made

An ancient primary

Throughout history, the range of hues between red and orange have been considered the strongest, the most 'colourful', and feature prominently in the most traditional application of art and colour – religious icons. This shrine in Varanasi is to the Hindu deity Hanuman.

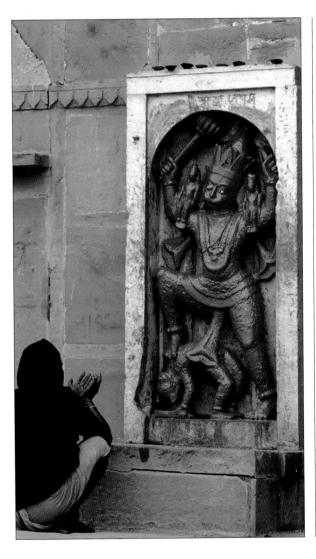

up from red, green, and blue, but this is a relatively recent concept. As the colour historian John Gage notes, anthropological studies of language have revealed 'the much older and more universal set, black, white and red,' because 'the earliest colour categories were those of light and dark, followed almost universally by a term for "red".'

Before the idea of mixing colours entered the scene as a way of defining primaries, they were identified by different processes, some intuitive, others related to the materials. Theophrastus in the late 5th century reported that Democritus argued for four 'simple' colours: black, white, red, and green. Aristotle identified five unmixed colours: crimson, violet, leek-green, deep blue, and either grey or white. In the Middle Ages, red, yellow, and blue were used not because they mixed to produce other colours but because they were the three most prized colour materials: vermilion,

gold, and ultramarine. Moreover, some of the earliest notions of basic primaries linked them to fundamental concepts such as the four elements (earth, air, fire, water) and to the seasons. Even Leonardo da Vinci had views on this.

With the development of sophisticated oil painting technique in the 16th century, the mixing of pigments to create new colours became more important. Pigments had, of course, been mixed for as long as man had painted (the oldest known artifact is a guarter-million-year-old mortar used for this purpose), but now the theorists began to take part. Agreement gradually settled through experiment on the three colours red, vellow, and blue as what became known as the 'painters' primaries', and these remain valid today, even though they are clearly apart from the RGB used in digital imaging. There is a major difference in the way colours can be mixed between paint and light. Using paint and painters' primaries is intuitive and seems natural, and this is colour by reflection. Mixing coloured light, however, produces different results that are not intuitive. Red and green, for example, produce yellow, which is not what the eye expects. This method of mixing is how digital cameras, monitor screens, colour film and, incidentally, our retinas work, which makes it highly relevant for photography, but it is at odds with the mixing of pigment on paper. Instead of red, yellow, and blue, the

three primaries for transmitted light are red, green, and blue. This fact became known well before coloured lights could be projected by the trick of spinning a disk on which colours were painted. However, a comparison between the two systems, reflected and transmitted, is impossible to reproduce accurately in any one medium, and here on the page the reflected colours print the more accurately. The transmitted primaries RGB are spectral, and for true accuracy you should view them on your monitor they look brighter and more intense than their equivalents on paper.

Evoking colour by name

How we describe colours has a large impact on the way we feel about them and can influence whether we enjoy a colour, or dismiss it as uninteresting, or even dislike it. This happens even while shooting for colourist photographers, who may spot a colour in a scene as one of their favourites. Two industries in particular know the value of names: house paints and make-up. Paint manufacturers are expert in selling chromatic greys (consider Dove Grey, French Grey and Ash White), while lipstick and nail polish manufacturers have sophisticated distinctions between reds (Matador, Orient, Calypso, Dubonnet and Metal Garnet to mention just a few). In a photograph, one person's 'drab pale green' can become another's 'luminous jade'. This all goes to show that you can decide to make any colour special by defining it in your own way.

Hue

The fundamental quality of colour is hue. Hue is very much the prime quality of a colour, and is what gives the colour its uniqueness. When most people refer to 'colour', they usually have in mind the hue – the quality that differentiates red from blue from yellow, and so on. In fact, we prefer to give names to colours than to give qualified descriptions. 'Crimson' sounds more precise and identifiable, for instance, than 'red with a touch of magenta', and 'ochre' a more natural definition than 'dark yellow'.

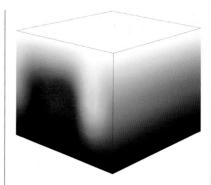

Colour cube

Hue is one of three qualities of colour that can be measured in the HSB model (see previous pages). One illustration of the relationship is a cube, shown here with hue changing horizontally across the left face, saturation horizontally across the right face, and brightness vertically across both from a black base to a white top.

Blue-green

As we will see later in this chapter, blue and green shade into each other more than do any other adjacent hues. From colour linguistics comes evidence that some cultures do not distinguish between them in name. The Mayan languages had only one word for both. Perhaps significantly, one of the key materials in Central American religious art was jade, of a colour that most Westerners would describe as 'blue-green'.

RGB versus RYB

The three standard reflected-light primaries – red, yellow, and blue – mix as pigments, inks, or dyes on paper to give the intermediate colours shown, with an almostblack when all three are superimposed. The equivalent mixture for the three transmitted-light primaries – red, green, and blue – is by projection, and they combine quite differently, with white as the result of all three together. Thus there is no simple way to square these two primary systems with each other; each is perfectly valid. Moreover, it is not just a matter of physics – reflected light versus transmitted light – because of the psychological component of colour. Colours are primary not only in the sense that they can be mixed to create all others, but also in that we perceive them to be in some way basic and important. The reflected and transmitted primaries have red and blue in common (with the proviso that they are not the same between the two systems), and differ in yellow and green. Yet, on psychological and cultural grounds, neither yellow nor green can be ignored, and this argues for four primaries. Indeed, the painter Mondrian argued for just these four instead of the more usual three.

My solution at this point of the book is to consider red, yellow, blue and green as the most important perceptual primaries but, so as not to offend purists, everything is arranged in the traditional order of painters' primaries and secondaries. We are, after all, in this first chapter introducing colours as they appear and with their associations. Making and manipulating colours digitally is another matter for a later chapter. Before experimenting with the ways in which colours combine, we'll take a long look at each of the principal hues, one by one. The three or four primaries and the secondaries have distinct characteristics, and understanding the personality of each lays the foundation for appreciating the wide range of colour relationships.

Colour associations

From the earliest times, individual primary colours have been associated with other basic elements of life, from the elements to seasons.

Earth

Black (Antiochos 2ndC) Ash-colour (Alberti) Yellow (Leonardo, Theon of Smyrna)

Air

Red (Antiochos 2ndC) Blue (Alberti, Leonardo, Theon of Smyrna)

Water

White (Antiochos 2ndC) Green (Alberti, Leonardo, Theon of Smyrna)

Fire Yellow (Antiochos 2ndC) Red (Alberti,

Leonardo, Theon of Smyrna)

Alberti = 15th century Renaissance Florentine artist and theorist

Spring

Red (Antiochos) Green (Alberti) Red (Theon of Smyrna)

Summer Yellow (Antiochos) Red (Alberti) Blue (Theon of Smyrna)

Fall Black (Antiochos

Black (Antiochos) White (Alberti) Green (Theon of Smyrna)

Winter White (Antiochos) Dark (Alberti) Yellow

(Theon of Smyrna)

Different ideas of primary colours

To illustrate the diversity of opinion over what the most basic and most important colours are, the following sets have all been considered primary:

Black, white, and red is the most ancient and primitive set, revealed by colour linguistics.

Black, white, yellow, and red was Pliny the Elder's view in the 1st century.

Aristotle identified five colours, which he named crimson, violet, leek-green, deep blue, and grey or yellow.

Democritus in the 5th century mentioned black, white, red, and green.

Black, white, red, and blue were listed by the French philosopher Louis de Montjosieu in 1585.

Black, white, red, yellow, and blue were the primaries identified by Irish chemist Robert Boyle in 1664.

Red, yellow, and blue had by the 17th century become accepted as the three painters' primaries (black and white being treated as modulating the colour).

For Mondrian, green needed to be added to the three-colour set, to give red, yellow, blue, and green.

Red, green, and blue are the spectral primaries used in sensors, film and computer monitors – that is the primaries of transmitted rather than reflected light.

Vermilion, gold, and ultramarine were the most expensive three colours available to Renaissance painters, and so had an elevated status in commissions, and this also influenced the choice of primaries.

Project: A colour library

Almost all colours derive from the six primaries and secondaries on the following pages (and from dilutions with white, black, and grey). After looking at the examples given here, a valuable exercise in colour discrimination is to go out and photograph your own versions. For the single colours, search out as many different ways of producing them as you can; don't limit your effort to paintwork on buildings and similarly easy versions. In the process of looking for the purest examples of each colour, you should find that some hues are more widely distributed than others, and that some are adulterated more often than others. The ubiquity of clear skies makes blue an easy colour to find, while violet is relatively rare in any quantity. Store the digital images without adjustment; that step comes later.

Colour and shape

There have been many attempts to reconcile basic elements and colours with basic geometric shapes, from the rendering by Nicoletto Risex in 1507-15 of the legendary ancient Greek painter Apelles, to the Bauhaus pronouncements of Itten and Kandinsky in the 20th century.

Square – earth Triangle – fire Circle – water Octagon – air

(Itten, Kandinsky) Circle – blue Triangle – yellow Square – red

Saturation

Pure hues are fully saturated, meaning that they are at full intensity, while most of the colours that we meet in life are a lower percentage than this, all the way down to a completely desaturated grey. Hue, as we just saw, is the first parameter of colour according to the way we perceive it. The others are saturation and brightness, and both are modulations of hue. Saturation, also known as chroma, is a variation in the purity of a colour, its intensity or richness. At one end of the scale are the pure, intense colours of the colour circle. As they become less saturated, they become more grey, 'muddier', 'dirtier', and less 'colourful'. In the physical world, rather than the digital photographic one, pigments, dyes, and paints

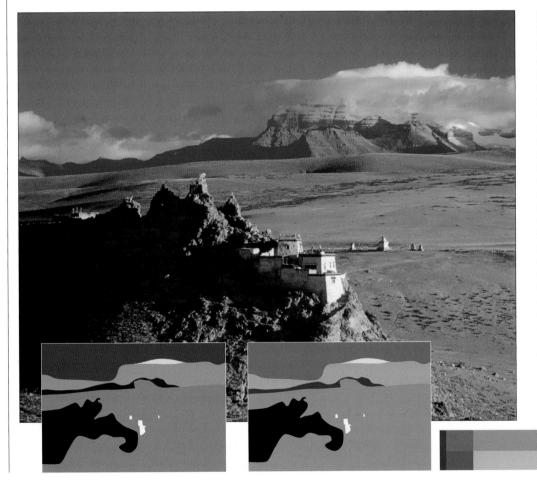

Nature's less-thansaturated colours

Fully saturated colours are rare in nature, and tend to be very localized, as in flowers and the pigmentation of some animals. Even what we might react to as a strong blue sky is, in reality, guite adulterated. The scene here, from an altitude of 16,500 feet (5,000m) in the Tibetan Himalayas, illustrates the point. The clarity of the atmosphere and the altitude intensify the colours, and they look strong without comparison. But seen in a schematic way as blocks of colours and compared with fully saturated hues, the reality is more moderate.

become unsaturated when they are mixed with white, black, grey or their opposite colours on the colour circle, which are known as complementaries. The primary hues that we saw on the previous pages, and most colours that we describe without qualification (such as 'blue' rather than 'cobalt blue') are fully saturated, and any variations are in one direction only - towards grey. In nature, particularly on the grander scale of landscapes or panoramas, most colours are unsaturated.

Most photographic subjects are things that the photographer has discovered, rather than built themselves, so adulterated or broken colours are the staple palette. In nature, greys, browns, and dull greens predominate, and it is for this reason that the occasional pure colour is often prized and made the feature of a colour photograph when found. Rich colours are therefore more often seen as desirable by the majority of photographers than are pastel shades. There is no judgment intended here – rich combinations and pale combinations can make equally powerful images – but it goes some way to explaining the attraction of intense colours. If they were a more dominant component of the landscape, more photographers would perhaps be drawn toward the subtler shades.

Brightness

As these two cross-sections of an HBS (HVC) solid show, different hues show maximum saturation at different levels of brightness. Thus yellow is most saturated when brighter than, say, purple.

Hue

Hue, brightness (value), and saturation (chroma) each occupy an axis perpendicular to the others, to give a 3-D model. It is easy to see from this why Hue is measured as an angle from 0° to 360°.

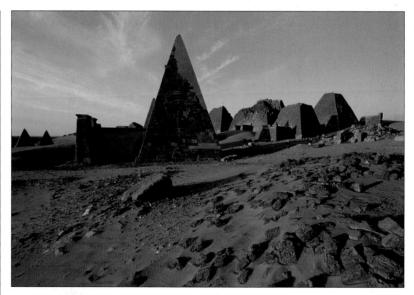

Saturation

On this image, of ancient pyramids in Sudan, a range of saturation has been applied from left (completely desaturated) to right (double the normal saturation). Choosing the appropriate level is not as easy as it might at first seem.

Brightness

The second modulation of hue is how bright or dark it is, and the maximum brightness depends on the precise hue, with yellow the highest and violet the lowest. **Brightness,** also known as brilliance and value, is the lightness or darkness of a colour; white and black are the extremes of this scale. It is sometimes a little difficult to distinguish brightness from saturation, but it may help to remember that, in varieties of brightness, the colour remains pure and unadulterated.

The actual range of lightness and darkness differs between hues, and this can cause difficulties in matching

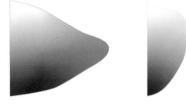

the brilliance. Yellow can only vary between a medium tone and very light; there is no such thing as a dark pure yellow. Red, as you can see from the scale opposite, becomes pink when very light, and so loses its main qualities.

Brightness and hue

As we saw on the previous page, the effect of brightness (value) varies according to the hue. Yellow, in other words, is always bright, becoming an ochre when darker, while purple is always dark, becoming mauve when pale. This is represented graphically in these two cross-sections of an HSB solid. Brightness is the vertical axis, saturation the horizontal, demonstrating that fully saturated yellow is brighter than fully saturated purple.

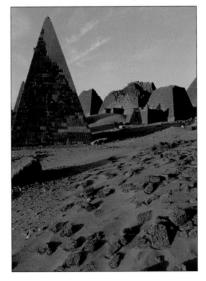

Altering brightness with light level

As shown in the progressive steps of this sequence, slight underexposure increases the intensity of hues while significant underexposure simply darkens them towards black. Overexposure reduces the primary characteristics of hue, creating paler and paler tones.

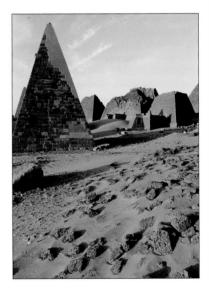

Blue, however, covers the full range. Orange, because of its closeness to yellow, does not have dark pure versions, but the range of greens is affected more by the blue component than by the yellow, and can be very light or quite dark. Violet changes its character at either end of the scale, becoming lavender when light, but hard to distinguish from deep blue when dark.

Brightness depends very much on the light level, and in photography is the one quality that can be changed most easily, by varying the exposure. Test this for yourself by photographing any scene that has a strong colour, and bracket the exposures over a range of several stops. The result will be a very accurately graduated scale of brilliance.

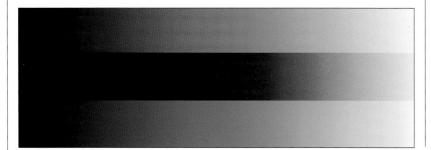

Brightness variation

A comparison of brightness value (from minimum at the left to maximum at the right). The hue value for the three primaries remains constant.

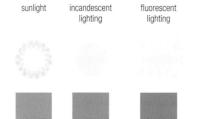

Colour and light source Because of differences in colour temperature,

between light sources (see pages 26-7), some colours vary in their apparent brightness. Blue, for example, is darker under blue-deficient tungsten light and the broken spectrum of most fluorescent strips.

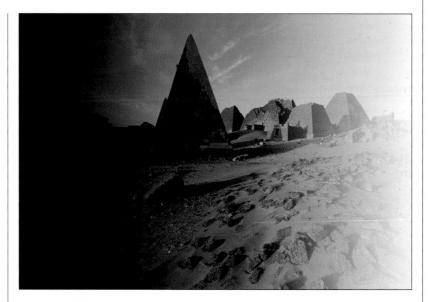

🗏 Brightness change only

Returning to the pyramid scene, its brightness alone has been altered from minimum at left (black) to maximum. Compared with the saturation variation, finding the best point along the scale is easier, but still flexible.

The colour of light

The first part of the colour equation is the wavelength of the light source – be it the sun, camera flash unit, or tungsten lamp – and it varies the whole breadth of the spectrum.

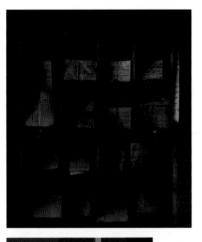

Low sunlight

Evening sun, filtering through a window in the Shaker village of Hancock, lights these boxes of herbs with a warm glow rich in reddish shadows. Indeed, colour and shadows make the main contribution to the image.

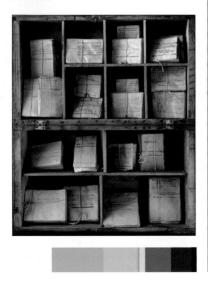

Optimized

As an experiment, optimizing this so that the paper is neutral and mid-toned shows how different, and less interesting, it would look were it not for the colour of the light.

Colour exists and functions at different levels, as already described, but it is at its most measurable and objective as a wavelength of light. And light fits in to a very small part of the electromagnetic spectrum, which includes X-rays, infra-red, radio waves, and other wavelengths, some of which are in one way or another important for us. This spectrum is continuous, between short and long, and the only thing that sets light apart from the rest is that we can see it. In other words, we make up our own definition for it. As Sir Isaac Newton determined in 1666 when he analyzed the visible spectrum with a prism, our eyes identify each wavelength in the narrow band between about 400 and 700 nanometers (nm) or millimicrons (10⁻⁹ meter or 1/1.000.000mm) with a particular colour for which we have a name. Traditionally (but it is only tradition), there are seven distinguishable colours in this spectrum, which in nature occurs most recognizably in a rainbow - violet, indigo, blue, green, yellow, orange, red. Nowadays it is more usual to divide the spectrum into six named segments, omitting indigo. Seen all together they appear as white, which is exactly the light we live by most of the time, from the sun when it is well above the horizon. There's no mystery in this. Our eyes evolved under sunlight and our brains treat it as normal basic, colourless lighting. And, as you already know from using the white balance menu in a digital camera, this is a practical, not a theoretical, matter.

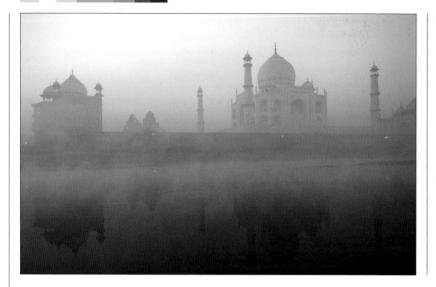

🖣 Taj Mahal

Before sunrise, mist over the Yamuna River catches mainly blue from the cloudless sky and magenta from just below the horizon in the direction of the sun. In the soft illumination at this time of day, the scene is suffused with a distinct colour combination.

The shortest wavelength that most people can see is violet, and the longest is red, and the fact that deep violet and far red appear to our eyes as very similar makes it possible to arrange all these colours conveniently in a circle, which we saw on page 16, but it's worth remembering this is just a construct. Violet at 380-450nm and red at 630-780nm don't actually 'meet'; they continue in opposite directions into ultra-violet and infra-red. Interestingly, unlike our other sense organs, our eyes cannot discriminate between the wavelengths - colours - in a mixture. We simply see a mix of wavelengths as one colour. When all the wavelengths are present we see them as white, while a sunset mix from, say, 570nm to 620nm we see as 'orange-red'.

Colours in the electromagnetic spectrum The electromagnetic spectrum is infinite, but even the 'useful' range for us, from X-rays and gamma rays to long-wave radio, is many times larger than the visible spectrum, from about 400nm to about 700nm. radio waves infra-red ultraviolet x-rays Violet 380-450nm Blue 450-490nm Green 490-560nm visible spectrum gamma rav Yellow 560-590nm Orange 590-630nm 630-780nm Red 780mm 630mm 590mm 560mm 490mm 450mm 380mm red sensitivity p cones scotopic vision rods 100 100

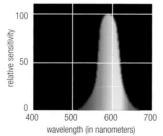

The eye and colour

The human eve is more or less sensitive to different

wavelengths, and as you might expect is most sensitive to

those in the middle, around yellow-green. For this reason,

yellow is for us always a bright colour, while violet is

always dark - explored in detail on the following pages.

There is also a difference in the eye's spectral sensitivity

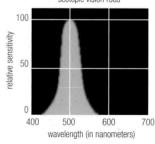

between dark and light. We see colour through the cones in the retina – the eye's photopic system – but at low light levels the colour-insensitive rods take over – the scotopic system. As the diagrams here show, the two systems peak at different wavelengths (see pages 94–95).

Colour temperature

A measure of the warm or cool appearance of a light source, colour temperature has lost much of its importance with the arrival of digital photography. An entry on colour temperature is mandatory for any technical book on photography, but I can't help thinking that it has become over-worked. The technical details are covered here in the boxes, but its usefulness in the real world of photography is, in these digital days, mainly as a guide to the change in the colour of daylight at different times of day. The ubiquitous white balance control in cameras and software has some relation to it,

but despite the fact that you now have opportunities to drag sliders across colour temperature scales marked in kelvins, it is probably less relevant to digital than to film photography.

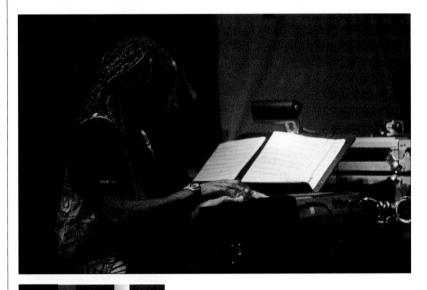

Clubbing Incandescent light, with a temperature of approximately 3200K, lights a Jamaican group playing in a New York club, photographed with a daylight White Balance setting.

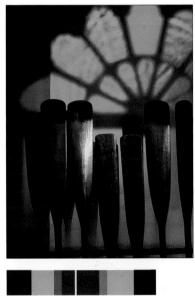

Afternoon

Light with a low colour temperature (yellowish) falling on objects that are already in the 'warm' part of the spectrum – oars against the wall of a royal boat house in Thailand.

26

This doesn't sound quite right, does it? After all the effort matching Wratten filters to light sources and choosing between daylight, Type B and Type A film, digital suddenly offers complete control - and yet it isn't as important? The thing about colour temperature is that it is a scientific measure that was co-opted by photography, mainly because it could handle the differences between sunlight and incandescent lamps (both sources burn and so they are on the same scale). Everything else, such as blue skylight and fluorescent lamps, was simply fitted in with greater or lesser accuracy. In fact, fluorescent lamps and vapour discharge lamps are not on the colour temperature scale. Ultimately, the goal is to able to choose the colour of the light as it appears in the image, and it does not matter whether the source is incandescent. reflections from other surfaces, photoluminescent, or vapour discharge.

Evening windows

With a daylight-balanced setting, the orange of lights through the windows of this Kyoto home contrasts with the rising colour temperature of evening light after sunset.

Skylight

A bright cloudless morning in New York. The warmth of direct sunlight contrasts with the higher colour temperature of blue sky reflected in the glass facade of a building on Park Avenue.

Shadows on snow

A Shaker building in Kentucky on a bright winter's morning shows the unexpectedly blue cast of shadows on fresh snow.

Colour temperature

The scale of colour temperature, from amber to bluish, is based on the colour that an object would glow if heated up to various temperatures. For consistency, the actual make-up of the substance is ignored, and is treated theoretically as a 'black body'. Measured in degrees kelvin, it has a special relevance to photography because most of the important light sources used for shooting lie on it. Heated beyond 1000K, a substance begins to emit light, but very red. Heating it more makes it glow whiter, and at 5800K, the temperature of the surface of the sun, the colour is exactly neutral white. Heated more than this. the colour becomes increasingly blue. Although the contrast between the two ends of the scale does not correspond exactly with the red-orange/blue-green contrast shown on pages 100-103, it is a fairly close match, and can be made use of quite easily, as the examples on these pages show.

The broken spectrum

The light from fluorescent and vapour discharge lamps often appears more strongly coloured in photographs than it looks to the eye, and needs special white-balance treatment.

Mercury vapour A floodlit Jai Alai stadium

in Miami glows bluegreen, but the intensity of the lighting washes out any trace of colour in the lamps themselves.

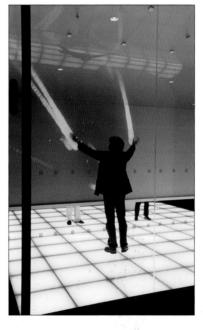

Two of the most efficient artificial light sources, used increasingly in interiors and outside at night, are vapour discharge (sodium, mercury, and xenon lamps) and fluorescent. Vapour discharge lamps work by passing an electric current through a particular gas, usually at a low density. Fluorescent lamps are, in effect, mercury lamps coated on the inside of the glass with phosphors - these are substances that absorb and then re-emit light. By adjusting the composition of the phosphors, lamp manufacturers can create different colours of light.

The problem for photography with these light sources is that they do not contain the entire spectrum,

yet the eye is able to accommodate this deficiency. The camera sensor, however, captures their light as it really is, often with a distinct colour cast. In film photography this could be corrected only by filters, but not always fully. Digitally, the white balance setting can cope with most of them, and further correction is possible later. In particular, most fluorescent lights are 'seen' as white whereas, in reality, the individual phosphors glow at distinct and different wavelengths. Their spectrum has gaps and spikes.

This seems, on the face of it, paradoxical. Why should the eye

register this kind of lighting differently from a camera's sensor – or film for that matter? The reason is, as already mentioned on pages 20–21, that the eye cannot differentiate between the different wavelengths making up the total colour experience. A trained ear can separate the several instruments

Display Banks of fluorescent lights underneath a translucent glass floor create a bluish glow to this interactive display by Bloomberg in Tokyo. in an orchestral work, and a trained palate the individual flavours in a dish, but even with experience there is no way to educate the eye to see the components. This is an advantage with brokenspectrum lighting because, whatever the gaps, it is still possible to create the effect of white. Captured by a sensor, or by film for that matter, the light from most fluorescent lamps is bluish-greenish and, for various psychological reasons, a greenish colour cast is thought of as unattractive by most people.

The basic correction is performed in the camera from the white balance menu, where there are, depending on the make of camera, one or more settings for fluorescent light. These can often be further adjusted by a few degrees of hue. Alternatives are to use the automatic setting (particularly valuable if the fluorescent lamps are mixed with daylight, tungsten. or other sources), or to create a special pre-set white balance by taking a reading from a sheet of white paper (the procedure varies according to the camera).

As for vapour discharge lighting, there may be no complete correction possible because some wavelengths are missing. This is certainly the case with sodium lamps, commonly used in street lighting and floodlighting, which looks yellow and lacks blue. Often the best that can be done with this digitally is to go for a desaturated, almost monochrome, appearance.

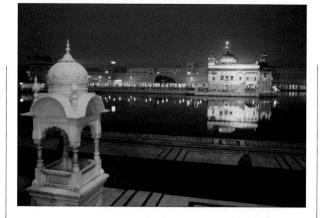

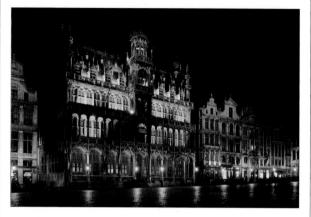

At Amritsar's Golden Temple, the perimeter buildings around the lake are lit by mercury-vapour lamps. The contrast with the incandescent lighting on the Golden Temple itself makes a positive contribution to the image.

Floodlight

The facade of the famous Grand-Place in the centre of Brussels is lit at night principally by sodium-vapour floods, which have a characteristic yellow cast from their extremely narrow spectrum.

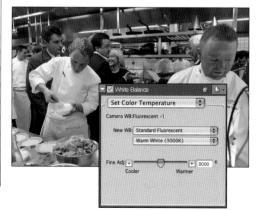

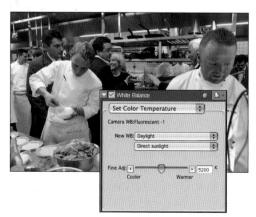

Software

The advantages of shooting Raw are obvious in the uncertain results of a strip-lit interior, in this case the kitchen of a famous St Moritz hotel. The setting at the time of shooting hardly matters (here Daylight), as the Raw converter allows full choice retrospectively.

The colour of objects

The second element in the equation of colour is the surface struck by the light. According to its composition, it can reflect, transmit, and absorb the light selectively, and this makes an object 'coloured'. Leaves are green, Caucasian flesh is pinkish, a marigold is orange, and we know these are intrinsic properties of the things themselves. This is common sense, but has implications that are easily overlooked in digital photography when colour is being adjusted. The final colour that we see, and that the camera records, depends not only on the light source but also on the surface it strikes. Because the menu settings on digital cameras place so much emphasis on measuring the

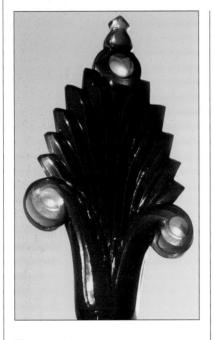

Red glass

Coloured glass has a long history in decoration, from stainedglass windows in European churches to this finial on the roof of the Lake Palace, in Udaipur, India. colour of light and adjusting the sensor's response to it through the white balance, it's easy to overlook the contribution of the objects in the scene.

The composition of a surface determines among other things how much light it reflects, transmits and absorbs. A coat of glossy white paint reflects a high proportion of the light, transmits none (it is opaque), and absorbs very little. Most of the light, therefore, is reflected right back. A piece of black cotton velvet, by contrast, reflects hardly any light, transmits none, and absorbs most of it. This seems blindingly obvious because of the way we describe objects and surfaces. However, with the exception of white, black, and grey objects, every other surface reacts to light selectively, meaning that

Refraction and colour

Refractive Index (RI) is the ratio between the speed of light in a vacuum (such as the sun's light reaching Earth), and the slower speed in a transparent substance (air, glass, water, for example). The higher the RI, the more the light is slowed down, and if the light strikes the surface at an angle, it changes direction – the basis of lens optics. From the point of view of colour, RI is important because it is different for different wavelengths. It is lower for long wavelengths like red and higher for short ones. Prisms and raindrops, for example, break up the spectrum because of this.

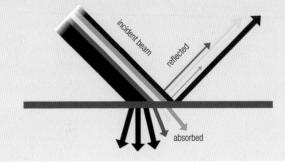

it favours some wavelengths – colours – more than others. Reflection and absorption work together inversely. Most fresh leaves are green because they absorb so much red. A daffodil appears yellow because its petals absorb blue.

Transparent materials transmit more light than they reflect or absorb, and when they do this selectively (like the acetate in 3D glasses) they appear coloured. Moreover, the effect builds up with depth – normal glass absorbs a little red, so thick slabs take on a greenish tinge, while water absorbs first red, then yellow and continues until, far below the surface, the colour is simply blue, an effect well-known to underwater photographers, who need flash to restore the lost colours. Seawater cupped in your hand seems colourless but 30 clear feet (10 meters) of it over white sand, seen from above, appears a strong blue.

Metamerism

Certain colours that appear to match under one type of lighting look different under another type. This happens quite strongly between daylight and tungsten, and between daylight and some fluorescent light.

Coloured objects, coloured light

The equation is more complicated when the light source is coloured. In orange early-morning light, leaves that are normally green appear quite dark because their red absorption is working on a higher proportion of the total light. And when the light is very strongly coloured, as in sodium-vapour street lighting, any surface that absorbs that particular wavelength will look almost completely black.

Colour with depth

An aerial view of shallow waters off an island in the Philippines illustrates clearly how increasing depth (here from the bottom to the top of the image) renders the appearance of seawater first green, then blue.

Red

Visually, red is one of the most insistent, powerful colours, and immediately attracts attention, in addition to having many strong associations. When set against cooler colours, greens and blues in particular, red advances toward the viewer, meaning that it seems to be in front of the other colours and, under the right conditions of subject and colour intensity, can bring a genuinely perceptible threedimensional effect. It has considerable kinetic energy, and produces some of the strongest vibration effects against other colours, as we will see later (pages 92-95).

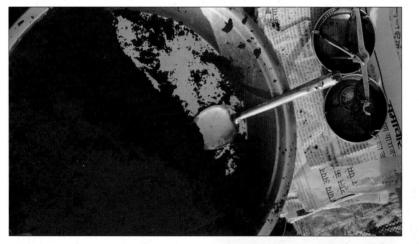

Tilak The red dot painted in the centre of the forehead in India is so widely used that mounds of the red powder are a common sight in markets all over the country.

Objects bathed in redfiltered artificial lighting take on a peculiar tonal quality. Deep shadows are virtually black, but highlights remain red, and do not lighten as would be normal in a full spectrum. The result is a limited tonal range. You can reproduce this effect by using a Wratten 25 red filter over the lens in normal light.

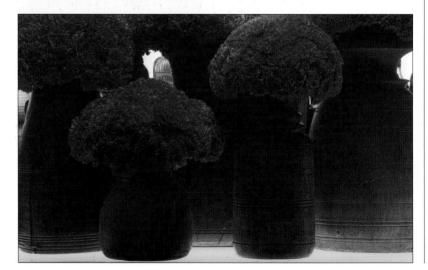

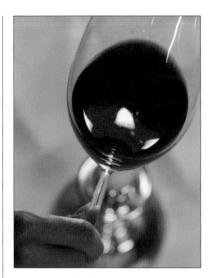

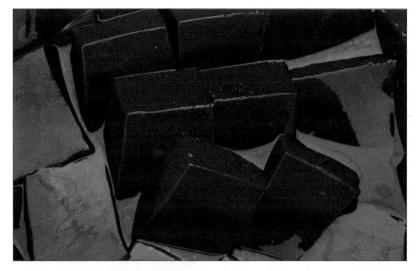

Red wine

To better analyze the subtle distinctions of hue in wine, a French sommelier uses the warmth of candlelight in the traditional manner. Viewed through the glass, this flickering light has the advantage of a known colour temperature, and being redder than daylight renders the appearance of the wine brighter.

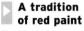

Along the northeastern coast of America, red has long been a favoured colour for timbered barns and other buildings. This striking example is in New Brunswick, Canada.

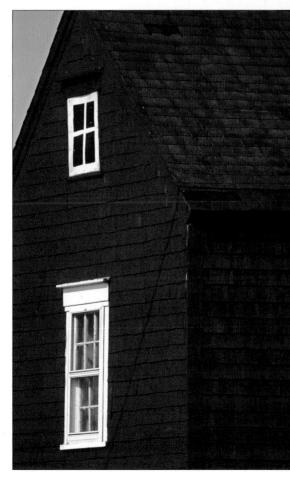

Primal colour

An image that is usually better received by viewers before they know what it is of – blocks of congealed pig's blood on sale in a northern Lao market. Nevertheless, blood is one of the key associations of red.

Vermilion

33

The preferred choice of pigment for painters throughout history, vermilion has always been the most intense. This antique block is being used in a scriptorium for the creation of a handwritten Bible on parchment.

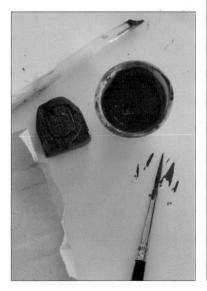

Postbox

Red pillar boxes are an icon of British streets, along with telephone boxes and London buses, to the point where it is considered as basic red in the culture.

Reds	
FIREBRICK	
BROWN	
DARK SALMON	
SALMON	
LIGHT SALMON	
ORANGE	
DARK ORANGE	
CORAL	
LIGHT CORAL	
TOMATO	
ORANGE RED	
RED	
HOT PINK	
DEEP PINK	
PINK	
LIGHT PINK	
PALE VIOLET RED	
MAROON	
MEDIUM VIOLET RED	
VIOLET RED	

In contrast to the transparency and luminosity of yellow, red is relatively dense and solid. In terms of its characteristic of redness, it has considerable latitude; in other words, it can move a way toward orange or toward violet and still be seen as essentially the same colour: red. While yellow can be felt to radiate light, red radiates the most energy. Emotionally, red is vital, earthy, strong, and warm - even hot. By extension, red can connote passion (hot-bloodedness) in one direction and, in the other, the infernal, aggressive, and dangerous. If we add the obvious association with blood, there are connotations of warfare and fiery destruction. The temperature associations have obvious origins, and indeed red is commonly used as the symbol for heat. Perceived as a very powerful colour, it is a symbol for

warning and prohibition, such as to indicate 'stop' at traffic lights. Red has also, from its expressive associations with blood and war, been a symbol of political revolution. During the Chinese Cultural Revolution some traffic lights were left unused because of the conflict between its prohibitive and revolutionary meanings! In Suprematist Russian painting in the 1920s, red stood for revolution as an intermediary colour in a sequence that began with black and ended with white for pure action. From the perspective of celebrity culture, red acknowledges power too – what award ceremony would be complete without a red carpet?

An essential indicator is, as always, how most people refer to a particular colour and, among all the hues, red seems to cause less confusion across cultures and time than others (see pages 12-15 for the confusion of blue with green). At the far end of its bluish range, it produces a variety of exotic hues, including magenta and purple. Even when adulterated toward russet, and when dark, red remains recognizable.

Red is fairly abundant for photography. It is relatively popular as a paint finish on buildings, vehicles, and signs. In nature, many flowers are red, and display interesting varieties of hue. Indeed in nature red is often associated with warning too – poisonous animals advertise their danger to predators via the colour. Embers and other burning things glow red at a certain temperature, and the richest of sunsets and sunrises – when the sun is extremely low – are red, lighting clouds to the same colour. **Red lacquer**

The Asian craft of lacquer makes use principally of black and red. In this modern Japanese piece, a red lacquer surface contains a circular depression to hold water. Reflected blue sky through the window adds a purplish-magenta tone to the highlights.

A wide range and yet still red

Perceptually, red covers a wide range of hues. Artist Chris Cook works with paper dyed in variations of standard Chinese red – all of the hues here fall indisputably within the term.

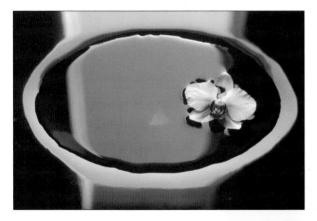

Red frequently takes on religious significance, as here on Corpus Christi Day in a Venezuelan town, where dancers perform in masks and cloaks of red through the streets and in front of churches.

Yellow

Yellow is the brightest and lightest of all colours, and this brilliance is its most noticeable characteristic, which accounts for the way it is used practically and thought of symbolically.

Indeed, yellow does not exist in a dark form -

if it is degraded with black, it simply becomes an earth colour between brownish and greenish, but a dark yellow is still brilliant in comparison with all other colours. As it is most often found set against darker tones, yellow often seems to radiate light in a picture. Matching its brilliance with other colours is difficult: a similar blue, for example, would have to be quite pale.

There is very little latitude in yellow; to be pure it must be an exact hue, while even a slight tendency toward yellow-green is obvious. All colours have a tendency to change character when seen against other colours, but yellow is particularly susceptible, as the pair of photographs here illustrate. It is most intense against black, and most insipid against white. Out of orange and red it extends the spectrum in the direction of brightness. Against violet and blue it has a strong contrast.

Expressively, yellow is vigorous and sharp, the opposite of placid and restful. Probably helped by association with lemons (a commonly perceived

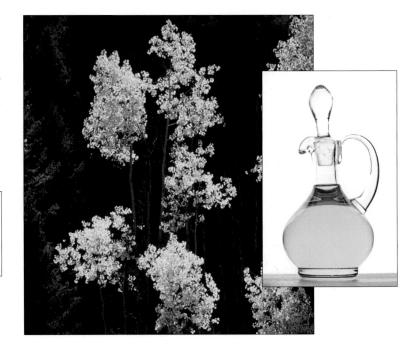

A very limited hue

With pure yellow in the centre, this space moves left toward green and right toward orange. Only personal taste can set these limits, but for most people yellow quickly turns into green on the one side and orange on the other. Most people have little tolerance for a contaminated yellow.

yellow green	'lemon'	yellow	'golden'	yellow orange
	-			

Yellow's variable energy

As the colour squares demonstrate, a bright colour like yellow receives energy from a dark setting, but is drained by a pale one. The central yellow square is identical in each. Far from being an exercise in optics, this has a real impact on photographing yellow. The yellow of the oil in the flask is actually more saturated than the aspen leaves, but the shadowed slope behind the trees on a Colorado hillside makes them seem distinctly more colourful and intense. Both oil and leaves are backlit and so show the full colour without being diluted by surface reflections.

Blue

This is a quiet, relatively dark, and above all cool colour, very common in photography and with a wide range of distinguishable varieties. **Blue recedes visually,** being much quieter and less active than red. Of the three primaries, it is the darkest colour, and it has its greatest strength when deep. It has a transparency that contrasts with red's opacity. Although pure blue tends toward neither green nor violet, it has a considerable latitude, and is a hue that

A beach in the tropics

A classic scene of palm trees overlooking shallow reefs in the Caribbean. Compare the colour with that of the aerial view – seen from ground-level, the water reflects the brighter, paler sky closer to the horizon. Pale green water in the distance is evidence of very shallow coral reefs. many people have difficulty in discriminating. Identifying a pure, exact blue is less easy than identifying red or yellow, particularly if there are no other varieties of blue adjacent for comparison. A valuable experiment is to shoot and then assemble a number of images, all of which were of things you considered to be 'blue'. The variations in hue are often a surprise; without colour training, the eye tends to imagine that hues are closer to the standard of purity than they really are.

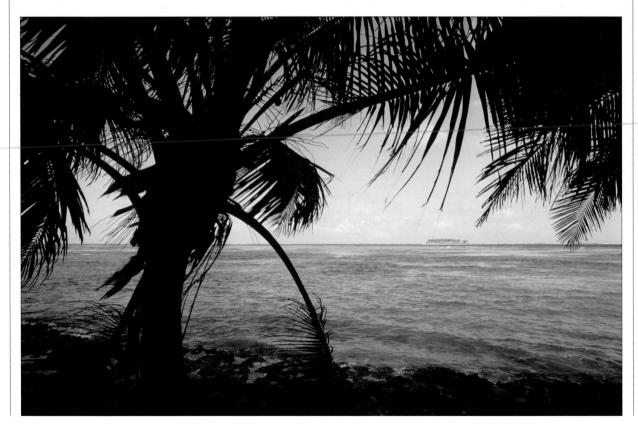

One of the most interesting variations of yellow, which it shares with orange, is gold. As a metallic colour, this is more fully explained on pages 122-123, and the key to photographing it is to capture the complex play of reflected light, shadow and colour across its surface. The colour of gold varies with its purity (the traditional method of making an assay was to judge the colour of its streak when rubbed hard against a black stone), from high-carat yellow to low-carat copper-toned. In photographs of gold, yellow is usually found in the shiny highlight areas.

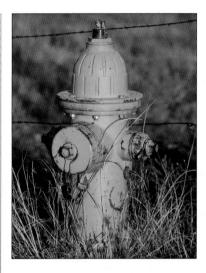

White balance and yellow

An American fire hydrant photographed late in the afternoon turns orange in the warmer light (left). Although by no means either wrong or objectionable, it does pose a problem: we know from experience that fire hydrants are

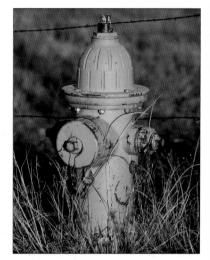

less red than this, and while the effect is quite logical, some people might prefer to see the hydrant as remembered. Depending on taste, this may be a case for adjusting the white balance on the camera's menu (right).

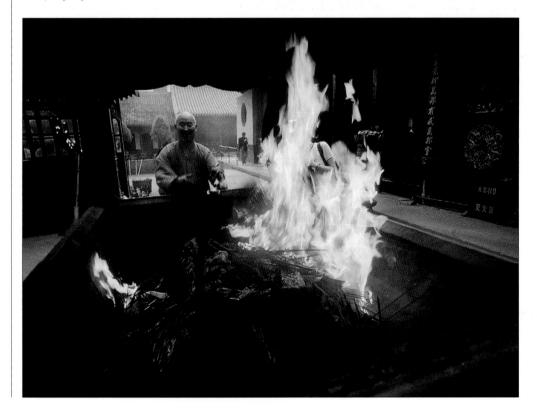

Flame

For the same reason that yellow is associated with the sun (incandescent light), it appears in the brighter part of flames, as in this Chinese temple. The hottest parts of the flame are both less red and brighter, and these two effects combine to make the centres of the tongues yellow.

Bathed in yellow

Although pale, the yellow cast over this scene in a remote hill-tribe village on the Burmese border is unmistakable. The reason is the heavy burning of swiddened fields in the dry season before planting. This haze lowers the colour temperature while the sun is still way above the horizon.

The yellow in gold

Varieties of yellow can be found in gold surfaces. The purer the gold, the less red and more yellow the hue, but this is always modulated by the surroundings, which the metal reflects.

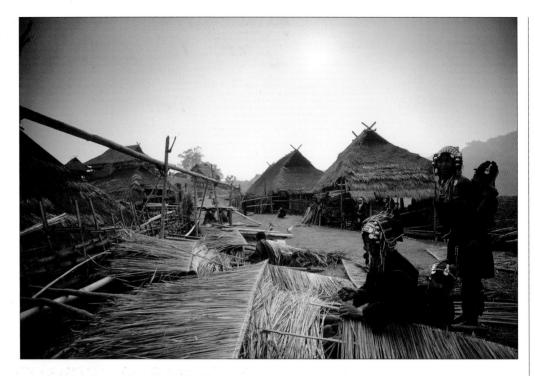

From dark to light

A recognizable yellow inhabits a restricted area. In this yellow colour space hue changes from left to right, brightness decreases upward, and saturation decreases downwards. The colours that most people would call yellow are in a shallow zone in the centre. Beyond this they become something else. When it becomes paler and less saturated, yellow begins to play a much larger role in scenes, most commonly because of the yellow component in morning and afternoon sunlight. The hazier this is, because of dust or particles in the atmosphere, the more it suffuses and, as the photograph taken in a hill-tribe village shows, it can at times bathe everything in a creamy, pale yellow light. Shooting into the sun emphasizes this, particularly with a telephoto lens which is allowed to flare.

Yellow's association with sunlight is no mystery – it is a colour of heat, at least in its warmer, more golden tones. Look at the colour temperature scale on pages 22-23 and you'll see that pure yellow is not on it. However, in a photograph of flames, overexposed yellow-orange appears as a distinct, if slightly pale, yellow (and bright flames against a dark background acquire an extra impression of intensity, as we saw on the previous pages). The same happens with ordinary domestic tungsten lighting and with candles. Yellow also appears in a very specific way in one kind of artificial lighting, sodium vapour. Here, the broken spectrum (see pages 24-25) of the lighting records as a green-yellow, as the photograph of the Indian palace shows. form of yellow), it can even be thought of as astringent, and would rarely be considered as a suitable setting for a food photograph, for example. Other associations are mainly either aggressive or cheerful.

There is no clear line separating the expressive and symbolic associations of yellow (this is true of most colours). Much of its vigour derives from the source of its most widespread symbolism: the Sun (which actually appears white until it's low enough in the sky for us to look at it without discomfort). By extension, yellow also symbolizes light. A second symbolic association with a very concrete base is gold, although yellow-orange is usually more appropriate (see Metallics, pages 138-139).

In large-scale scenes like landscapes, pure yellow is not common, and tends to be found in specific objects. It tends to exist in smaller objects, like plants: buttercups, marigolds, daffodils, and leaves in fall; fruits like lemon, melon, and star fruit. Egg yolks also put in an appearance. In the mineral world, sulphur is the strongest yellow, but is rarely seen, since it is most likely to be found in nature encrusted around volcanic vents. As a paint and tint for man-made objects, yellow has a special popularity when the idea is to catch attention, as in road warning signs, school buses in North America, mail boxes in West Germany and fishermen's waterproofs. It is also used just to be bright and cheerful.

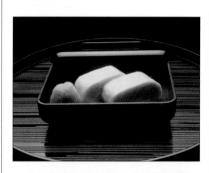

Egg

A Japanese dish, dashimaki tamago, is a rolled version of an omelette, and has the characteristic yellow formed by egg yolk mixed with egg white. Japanese food presentation is traditionally highly visual (one Japanese saying is that we 'eat first with our eyes'), and the yellow is accentuated by the choice of a dark red dish.

Yellow's simple brightness attracts people to use it as a paint whenever they want an object to stand out. The reasons for doing this may be functional (for safety and attracting attention) or for pleasure in a cheerful, vigorous colour, as with this small Mediterranean fishing boat.

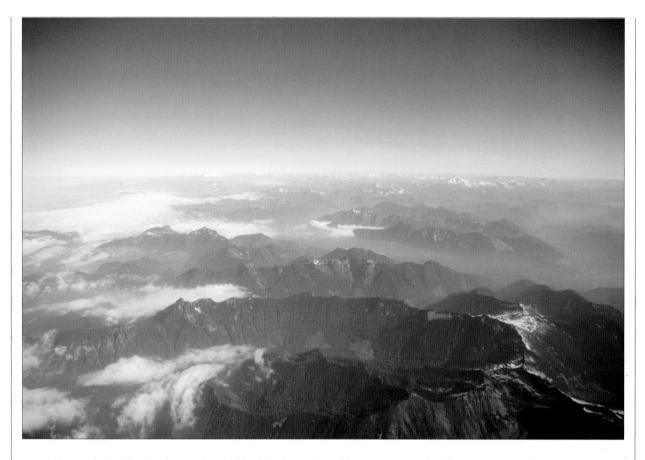

Expressively, blue is, above all, cool. Used in decoration, it even produces the sensation that the actual temperature is lower than it is. The contrast with red also occurs in other ways: blue has associations of intangibility and passivity. It suggests a withdrawn, reflective mood. The primary symbolism of blue derives from its two most widespread occurrences in nature: the sky and water. There are other, subjective, symbolisms; for example, the painter August Macke of Der Blaue Reiter (The Blue Rider, an expressionist group of the early 20th century) wrote: 'Blue is the male principle, sharp and spiritual...'.

Photographically, pure blue is one of the easiest colours to find, because of the scattering of short wavelengths by the atmosphere. The result of this is that a clear daytime sky is blue, as are its reflections (in the form of shadows and on the surface of the sea and lakes). Water absorbs colours selectively, beginning at the red end of the spectrum, so that underwater photographs in clear, deep conditions have a rich blue cast.

Aerial

A clear sky is the most accessible source of blue for photography, and is at its most intense at altitude – here a view of the Cascades in Washington State from an altitude of 30,000 feet (9,000 metres).

THE LANGUAGE OF COLOUR

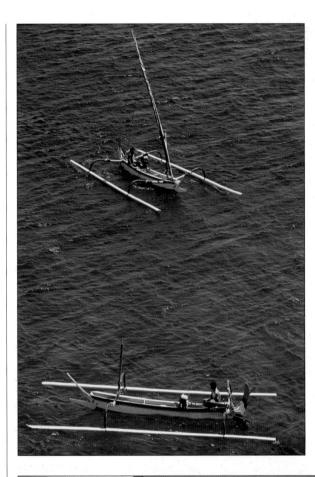

The deep blue sea

Three factors contribute to the unusually rich blueness of this aerial view of outriggers in the southern Philippines – clarity of the water, a cloudless, strong blue sky, and the angle at which it was shot (high, from a helicopter, with just the upper dome of the sky reflected).

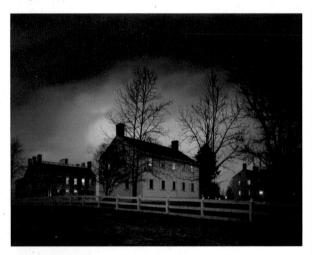

Greenberg House

The light blue of this building's colour scheme helps blur the lines between inside and out, working in harmony with the other architectural features like the floor-toceiling plate glass. This shade of blue is associated in the mind with a clear sky.

photography's most common and reliable sources of blue occurs after sunset and before dawn, when the only source of daylight is what remains from the sky. Shot with a daylight white balance, a Kentucky Shaker village takes on an austere and cool appearance.

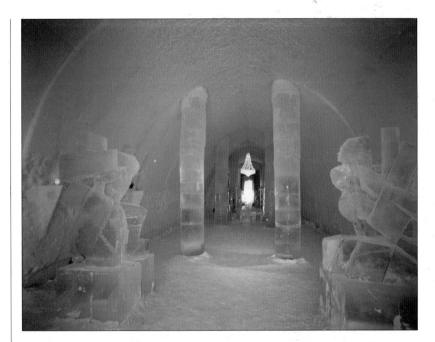

Jodhpur

The buildings in the centre of the Rajasthani city of Jodhpur, surrounding the fort, have traditionally been painted this rich blue colour, giving Jodhpur the name the Blue City.

lce Hotel

A hall of carved ice welcomes visitors to a unique hotel in the far north of Sweden, built afresh each winter from a particularly pure ice taken from the nearby Torme River.

Tool of the local division of the local divi	Blue	
1	MIDNIGHT BLUE	
	NAVY BLUE	
	CORNFLOWER BLUE	
200	DARK SLATE BLUE	
	SLATE BLUE	
	MEDIUM SLATE BLUE	
. 8	LIGHT SLATE BLUE	
	MEDIUM BLUE	
1		
_		
	ROYAL BLUE	
-	ROYAL BLUE BLUE	
-	BLUE	
	BLUE DODGER BLUE	
	BLUE DODGER BLUE DEEP SKY BLUE SKY BLUE	
	BLUE DODGER BLUE DEEP SKY BLUE SKY BLUE LIGHT SKY BLUE	
	BLUE DODGER BLUE DEEP SKY BLUE SKY BLUE LIGHT SKY BLUE STEEL BLUE	
	BLUE DODGER BLUE DEEP SKY BLUE SKY BLUE LIGHT SKY BLUE	
	BLUE DODGER BLUE DEEP SKY BLUE SKY BLUE LIGHT SKY BLUE STEEL BLUE	
	BLUE DODGER BLUE DEEP SKY BLUE SKY BLUE LIGHT SKY BLUE STEEL BLUE LIGHT STEEL BLUE	

Green

The key colour of nature, green is also the hue to which our eyes are most sensitive, and we can discriminate within it a large number of individual greens. Between yellow and blue, green has the widest distinguishable range of effects of all the primary hues. It can take on many different forms – depending on how yellowish or bluish it is – and each with distinct characteristics. Although it has a medium brightness, green is the most visible of colours to the human eye: at low levels of illumination, we can see better by green light than by any other wavelength.

Greens
DARK GREEN
DARK OLIVE GREEN
DARK SEA GREEN
SEA GREEN
MEDIUM SEA GREEN
LIGHT SEA GREEN
PALE GREEN
SPRING GREEN
LAWN GREEN
GREEN
CHARTREUSE
MEDIUM SPRING GREEN
GREEN YELLOW
LIME GREEN
YELLOW GREEN
FOREST GREEN

Green is the main colour of nature, and its associations and symbolism, for the most part positive, derive principally from this. Plants are green, and so it is the colour of growth; by extension it carries suggestions of hope and progress. For the same reasons, yellow-green has spring-like associations of youth. Symbolically, green is used for the same purposes as its expressive associations - youth and nature, with plant-life in particular. For a more specific example, green signifies 'go' at traffic lights, as opposed to the prohibition of the red 'stop' light.

🍸 Green pebble pond

A small pond created in a Tokyo garden to evoke the colours of the wooded Shinto heartland to the south of Japan, in which the designer has artfully included a special variety of green pebbles to the low undergrowth of ferns.

Comoros market

In the morning market in Moroni, capital of the Comoros Islands, unripe bananas blend with the seller's green attire – a colour popular for religious reasons in this Islamic republic.

Malachite

The most intensely green of all rocks is malachite, which has an intense, even garish hue similar to viridian. Here it has been used for the surface of an inlaid table in a converted Indian palace.

Forest green

Bright sunlight on dense foliage in a coastal forest on the Bay of Fundy, New Brunswick, reflects in the waters of a stream flowing around mosscovered rocks. A long exposure blurred the ripples and so enriched the green.

Turquoises	
PINK TURQUOISE	
DARK TURQUOISE	
MEDIUM TURQUOISE	
TURQUOISE	
CYAN	
LIGHT CYAN	
CADET BLUE	
MEDIUM AQUAMARINE	
AQUAMARINE	

Rainforest

As evident from the selection of images on these pages, chlorophyll is the enduring source of green in the natural world. Here it appears as an archetypal 'green world' of tropical South American rainforest under the Purace volcano in Colombia. In nature at least, greens are very common. Pure green, however, is not easy to find, as you can see by taking a number of images in this colour and comparing them with a standard reference. You can create one yourself to use as a digital colour swatch on-screen, using Photoshop or another imageediting program – set it to RGB mode if you're not already in it, and pick pure green with the colour picker (Red O, Green 255, Blue O in a standard 8-bits per channel image). Most vegetation is considerably adulterated and subdued toward varieties of grey-green, although leaves often show a purer green when backlit than they do by reflected light, something we examine in greater detail on the following pages.

Paradoxically, perhaps, given all these positive associations, an overall greenish cast to an image is usually considered unattractive. The psychological reasons for this are complex, but involve an overall innate preference for the warm, golden glow of sunrises, sunsets and the hearth. There is also, possibly, a minor negative in the association of green with the putrid. Most common varieties of mold are green or blue-green in appearance, such as the cladosporium, which grows on products as diverse as tomatoes, face creams, and fuel tanks.

A stacked-glass work by artist and sculptor Danny Lane glows green, due to the traces of lead inherent in most glass.

Monsoon colours

The ruins at Angkor take on a greenish hue in late summer, when the monsoon rains arrive. The vegetation that cloaks many of the ancient temples becomes lush, and moss grows back over hidden statues.

Jade If malachite is the crude green of the mineral world, jade is green at its most refined. Imperial jade is the green gem-quality variety of this favourite Asian stone.

Violet

The mixture of blue and red stands out among colours as being the most elusive of all, both in our ability to identify it and to capture and reproduce it photographically. Many people have great difficulty distinguishing pure violet, often selecting a purple instead. It is worth making your own attempts and then comparing these with the colour patches printed here. The difficulty in recognizing violet is compounded in photography by the problems in recording and displaying it. The gamut in colour monitors and printing inks is particularly unsuccessful with this colour. You can be reasonably

certain of testing this for yourself if you photograph a number of different violet coloured flowers. Pure violet is the darkest colour. When light, it becomes lavender, and when very dark it can be confused with dark blue and blue-black. If reddish, it tends toward purple and magenta; if less red, it simply merges into blue. The difficulty of discrimination, therefore, is in the zone between violet and red.

Burmese nuns

The garments of Burmese nuns at a convent in Sagaing, near Mandalay are pink and red, but in the bluetinged shadows on a clear day they take on violet notes.

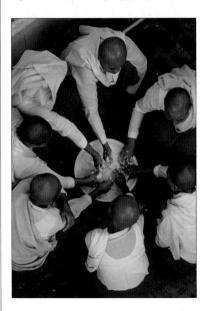

Vietnamese fireworks in a market stall for sale in the days leading up to the annual Tet festival.

Lavender fields

Lavender growing in rows in Provence, in the south of France, is also a colour definition in its own right, yet still falls within the broad range of violet as a secondary hue.

49

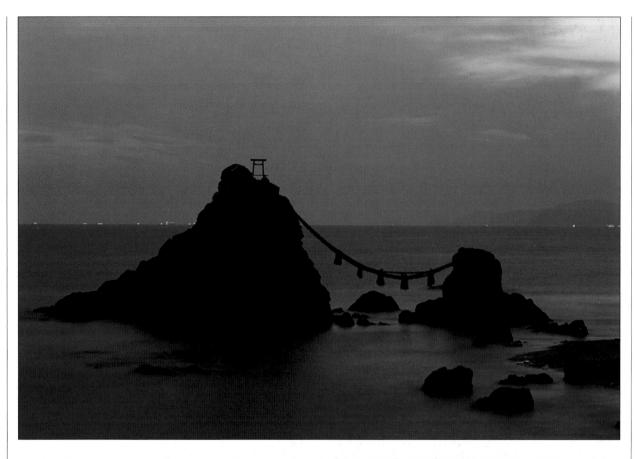

Violet has rich and sumptuous associations, but can also create an impression of mystery and immensity. A violet landscape can contain suggestions of foreboding and otherworldliness. By extension, purple has religious, regal, and superstitious connotations. Violet symbolizes piety in Christianity, and quasi-religious beliefs, including magic and astrology. It is sometimes used to represent apocalyptic events.

Violet is a relatively difficult colour to find for a photograph. In nature, some flowers are violet, but are often difficult to record accurately on film. The wavelength of ultraviolet used as 'black light' is recorded by a sensor as a pure violet. Under certain conditions, the light before dawn and after sunset can appear as a reddish version of violet.

Violets	
MAGENTA	
VIOLET	
PLUM	·
ORCHID	
MEDIUM ORCHID	
DARK ORCHID	1. 1. 2. C.
DARK VIOLET	
BLUE VIOLET	
PURPLE	
MEDIUM PURPLE	
THISTLE	

Dawn

Dawn and dusk produce a huge range of colours depending on the state of the atmosphere and weather, often with unpredictable results. Off the southeastern coast of Japan, the two famous rocks known as Meotolwa, tied together by rope, are backlit by a rich purplish sky that has not been enhanced digitally.

Orange

Combining the strong characteristics of its two neighbours, red and yellow, orange is a rich, radiant colour inextricably associated with the glow of incandescent light. Orange is the mixture of yellow and red, and absorbs some of the qualities of both. It is brilliant and powerful when pure and, since yellow radiates light and red radiates energy, it is by association very much a colour of radiation. When lighter, as pale beige, and darker, as brown, it has a neutral warmth. Orange is the colour of fire and of warm late afternoon sunlight. It has associations of festivity and celebration, but also of heat

	Oranges
	ORANGE
8	COPPER
8	COOL COPPER
8	CORAL
	GOLD
	MANDARIN
20	OLD GOLD

and dryness. Symbolically, it is interchangeable with yellow for the sun, and with red for heat.

In the world outside, pure orange can be found in flowers, and in a slightly adulterated form in the light cast by tungsten bulbs, candle flames, and other sources of low (less than 2,000K) colour temperature. In film photography an 85B standard filter (a dull orange) was used with type B film (film adapted for tungsten light) in daylight to compensate for the blue cast of the film, and this has a digital equivalent in colourizing tools such as Photoshop's Photo Filter (under *Image > Adjustments*).

Religious colour

In Japanese Shinto, this particular shade of orange, moving toward red, is a sacred colour, here painted on the torii gates lining a temple approach. Orange from heat Metal samples being heated in a laboratory furnace. A pure example of orange as colour temperature.

THE LANGUAGE OF COLOUR

Gold

Reflecting not just sunlight but neighbouring gold, a gilded chedi in northern Thailand glows a range of orange-toyellow.

Sikh guardians

Ceremonially attired guardians at the Golden Temple, Amritsar, in India, the focus of the Sikh faith.

Tiles

Rooftops in the centre of the old city of Bruges, in Belgium. The striking colour of roof tiles can be seen across the Benelux region of continental Europe and north into Denmark.

Almost red as it nears the horizon, the sun reflects as a shimmering band in the muddy waters of the Mekong River at Vientiane, the Laotian capital.

The fruit itself, of course, is the classic example of the colour.

Black

Black is the absence of light and tone, and in photography is produced simply by no exposure. While in its pure form it contains no detail, it is essential for establishing the density and richness of an image. **Black, being the extreme** of density and solidity and the base density of an image, needs the contrast of another shade or colour in order to make any kind of picture. As a result, it is used in images mainly as a background, as a shape (such as in a silhouette), or as a punctuation. Black can never be too dense; indeed, the limitations of a printed image on paper are often such that it appears weak, a very dark grey, and this subtly influences our appreciation of a

photograph in a negative way. This slight weakness is particularly unsatisfying in a black, which ought to represent a solid anchor for all the other colours and shades, wherever it occurs in a picture; hence the importance in making sure that a small area of pure black appears somewhere in the majority of images. Although, obviously, there are many photographs which cover a softer scale of tones and benefit from a gentle appearance – a delicate modulation in a foggy landscape, for example – most images tend to look satisfying to most people when they cover a range that has a pure, strong black somewhere in the scene. This is a natural perceptual response, and as such is the basis for the part of optimizing an image that involves setting the black point (see page 78). Overexposure, low contrast, and careless optimizing of a digital image will create this weakness in the base black.

Background

One of black's essential uses is to function as an empty background that, by contrast, throws an object forwards toward the viewer, here the lightly coloured shell of a Precious Wentletrap. It is easy to remove all traces of tone from the cotton velvet background through less exposure.

Silhouette

Lit background and shadowed foreground is the recipe for silhouette, as in this image of a monk meditating in front of Rangoon's Shwedagon Pagoda. A true black reinforces its 'silhouetteness', and from the original shot with its fuller range (left), the black point dropper in Photoshop was used to intensify the effect in the righthand image. Having said that, it is also very important for the success of a wellmodulated photograph to distinguish between details in the shadow areas, and this essentially means being able to discriminate between very small differences in the lower levels, particularly between 0 and about 20 in an 8-bit image (on a scale from 0 to 255). Extreme subtleties of tone in images that have blacks against blacks are interesting and challenging to explore (in painting Manet was able

to achieve what Matisse called 'frank and luminous black' in works such as *The Balcony* and *Breakfast in the Studio*). The master Japanese printmaker Hokusai discriminated between types of black: 'There is a black which is old and a black which is fresh. Lustrous black and matt black, black in sunlight and black in shadow'. He advocated a touch of blue to make black 'old'. The distinctions between lustrous and matt are, of course, familiar to any photographer choosing paper for prints. As a pure background, however, it can be either dense, like a solid wall, or empty, as in featureless space. If you want to guarantee that a studio background reproduces as pure black, you may need to use such a material, and then further deepen it in editing.

Where black shades to grey, the grey is very sensitive to its neutrality or otherwise. Any slight hint of a colour cast is immediately recognized, and then inferred to be a part of the blackest areas. If you do not set a neutral black point in an image, it is common to have dark shadow areas which actually contain a colour cast, though this may be difficult to see on a monitor screen. Boosting the monitor brightness temporarily will usually reveal this, as also of course will running the cursor over these areas and checking the RGB values.

The neutrality of black outweighs most of its associations and symbolism, but where it appears extensively in an image it can be heavy and oppressive. Nevertheless, it can also carry hints of richness and elegance. In the 16th and 17th centuries, most notably in 17th-century Holland, it was the colour of high fashion among the aristocracy.

Black swan

A variation on 'black cat in a coal shed', this image of a Black Swan against deep shadows relies totally on its white and pale grey highlights to give form and recognition.

White

Although theoretically white is the absence of colour and of tone, in practice it is the most delicate of colours and plays a very important role in almost every image. White is the absence of any tone whatsoever. Nevertheless, just as a black object must contain tonal highlights and modelling in order to be recognizable, so a white image needs at least the modulation of pale greys or off-whites in order to be a part of an image. These slight modulations are very susceptible to colour cast, however – even more than with black – and achieving complete neutrality is not

easy. (This is a problem chiefly associated with grey, and we examine it below.) One famous still-life painting, *The White Duck* (1753) by Jean-Baptiste Oudry, is a spectacular exercise in the subtlety of chromatic whites; the artist wrote: 'you will know by comparison that the colours of one of these white objects will never be those of the others'.

White on white

A smock hanging on the wall in Pleasant Hill Shaker village, Kentucky makes a study in white, but it is the shadows that define it and set the reference tone for the exposure.

Whites WHITE SNOW GHOST WHITE WHITE SMOKE

GAINSBORO

OLDLACE

LINEN

ANTIQUE WHITE

As with blacks, exposure is critical with white subjects, and if there is sufficient time, bracketing is recommended. Typically, without adjustment an image like this would need one *f* stop or more of extra exposure beyond that set automatically.

Photographically, white needs care in exposure, and more so now with digital cameras than with film. Slight underexposure makes it appear muddy; slight overexposure destroys the hint of detail and usually gives an unsatisfactory sensation of being washed out. Film has a non-linear response to exposure, which means practically that, even when you overexpose it significantly, it tends to retain some traces of detail. The sensor in a digital camera, however, has a more linear response - the photosites that make up a CCD or CMOS sensor chip continue to fill up at the same rate, in proportion to the exposure, right to the top. Once full, they cannot absorb any more information, so cannot register any further subtlety in shade. The effect is that it is easier to lose all detail completely with a digital camera, and the highlights are blown out, or 'clipped' as the condition is usually known. Although its neutrality robs white of strong expressive association, it generally symbolizes purity. It also has associations with distance and even infinity (as it was used by the Russian painter Kasimir Malevich in his White On White series between 1917 and 1918).

Neutral colours

Although they lack hue and fit nowhere on the colour circle, the three neutral shades of black, white, and grey are essential components of colour photography. Not only do they exist as counterpoints and setting for the colours just described, but they are mixed with these pure hues in varying degrees to make adulterated browns, slates, and other subdued colours. We should treat them as a special, but essential, part of photography's colour palette.

Stalks in snow

Snow, of course, is white, but that also means that it is highly reflective, and to appear pure has to be seen under neutral cloudy light. Even on an overcast day, a slight bluish tinge appears.

Cranes in winter

Japanese cranes on the northern island of Hokkaido, calling in the late afternoon. The small amounts of black plumage help give definition in another essentially whiteon-white image.

Grey

In its purest form, grey is the essence of neutrality, deadening the sensation of colour in proportion to its area in the picture. It also, valuably, helps to reveal any colour cast in a photograph. Without any qualifying description, grey is assumed to be mid-grey, and this has a special place in photography. Mid-grey is exactly halfway between black and white, and on the 8-bit scale of tones used throughout digital imaging (2⁸ equals 256, from pure black to pure white), it is 128 in all three channels. When printed, mid-grey reflects 18 percent of the light falling on it, and for this reason an 18 percent grey card, as it is known, is sometimes used for exposure

Heading
DARK SLATE GREY
DIM GREY
SLATE GREY
LIGHT SLATE GREY
GREY
LIGHT GREY

calculations; it is the standard for an average subject, and we deal with this technique on page 72. A through-the-lens reading of 18 percent grey gives exactly the same exposure value as a hand-held incident meter reading. Underexposing white or overexposing black produces any shade of grey, and if you use the camera's automatic exposure on either of these, the result will be a mid-grey. The digital white-balancing tools both in the camera (pre-set white balance, for example) and in image-editing software (such as a grey-point dropper) are designed to convert any selected colour to a neutral grey,

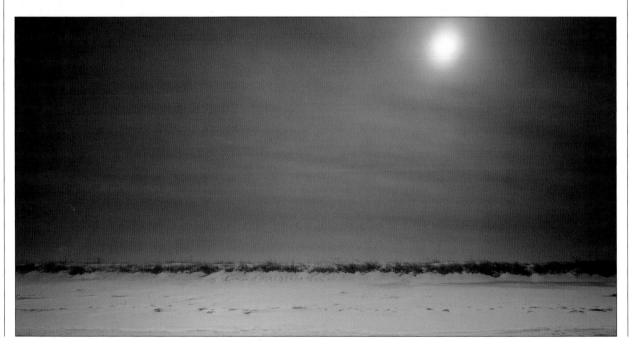

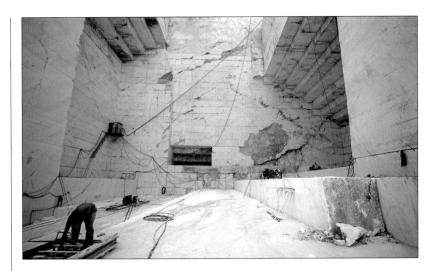

at the same time shifting the rest of the colours. Neutral density filters are also pure grey.

Nevertheless, the number of greys is almost limitless, ranging not only between black and white, but also varying in hue depending on slight colour casts. If a colour is heavily unsaturated, it becomes a type of grey rather than a greyish hue, and this is called a chromatic grey. As the examples here show, even slight hints of colour register on the eye - its very neutrality makes it a sensitive base for the slightest variation of hue.

Pure grey has leaden, mechanical associations, with connotations of being uninteresting (the word is used this way to describe people). Bluish grey expresses coolness; reddish and orange-grey warmth. Grey is the colour of stone, and so also borrows associations of solidity and weight. As a group, greys are very common, not only in nature (rocks, dark clouds, water on an overcast day) but in man-made environments (concrete, plaster, streets, buildings, smoky atmosphere). Pure neutral grey is difficult to record, however, because of the eye's sensitivity to colour bias. Use the colour block printed here (left) as a reference; better still, buy and use an 18 percent grey card from a photographic manufacturer (see page 70).

Carrara These are the Tuscan quarries from which the famous, and white, Carrara marble is hewn. The shadows must appear grey after editing.

Mothball fleet

Rows of naval vessels off the Californian coast. Grey is the standard paint for ships of all the world's navies.

A Massachussetts coast in the depths of winter under a leaden sky that has completely drained any colour.

Sacred elephants

At the sacred Buddhist site of Anaradhapura in Sri Lanka, a frieze of concrete elephants guards the sanctuary. Concrete and cement are standard recognition surfaces for neutral colours (see pages 74-75 on Memory Colours).

Neutral blacks, whites, and greys

Grey by definition is neutral, meaning no hue and no degree of saturation. However, in the range of tones in a photograph, it is possible to have the mid-grey neutral while the blacks and whites are tinged with colour. The core techniques of balancing colour digitally, as we'll come to on page 72, are setting all three to neutral – at least when they can be identified in the image.

Case study: chromatic greys

Because of its neutrality, its lack of 'colour', we are very sensitive to the accuracy of grey - or so we think. Yet ask any two people to point to a perfectly neutral grey and you're unlikely to find agreement. The measurable differences may not be far apart, but the opinions probably will be. Fortunately, the means for measuring exact neutrality are instantly at hand digitally, and RGB is for once the most easily read colour mode. In a truly neutral grey the three values are the same. We can easily distinguish slight differences in hue, though only when we see them side by side. This spread is more like a project with two objectives: to find and assign a full range of these so-called chromatic greys, covering at least the six primary and secondary hues, and to find the limits of grey; at what point with the addition of hue and saturation does the result become a distinct colour rather than a coloured version of grey? Naturally, there are no fixed answers.

Roots and stone Warmer greys are

wanner greys are found in a strange combination of the roots of a ficus that have grown around and lifted the head of a Buddha sculpture in the city of Ayutthaya, Thailand.

HMS Belfast

A light cruiser, launched in 1938, now moored near Tower Bridge, serving, in military grey, as a tourist attraction.

Morning mist

Another case for maintaining subtlety of hue and not simply making the scene neutral. The pale blues and greens of English fields below power lines help the sensation of a damp winter's morning.

Subtle desaturation

This is the full spectrum of hues, exactly as reproduced on page 65, with a vertical dark-to-light gradient, and 96% desaturation applied. This almostcomplete removal of saturation results in a range of colours that are more grey than anything else, yet still retain differences in character.

Blue mud

It's important when shooting near-neutrals to see and remember the subtleties of hue. The mud in which these Namibian elephants were bathing in Etosha was actually a pale blue. If I had failed to notice, I may later have 'corrected' them to true grey.

Working **Digitally**

With digital photography there is both the necessity and opportunity to control and adjust colour in ways that are completely new to photography. The necessity is because, unlike with film, there is never a single point in the process at which the colours of an image are fixed. Traditionally, and with slide film, the moment of exposure established how the colours would appear. You could change the way it was printed, either in the darkroom or in repro, but the original slide would always remain the reference. Digitally, the image is captured with much more flexibility, and the colour of each individual pixel is open to change at any point afterward. If the photograph is captured in Raw format, the settings (including white balance) are kept separate from the data and can be revisited at any time.

The opportunity lies in choosing exactly how any and every colour should look, regardless of what it was in the scene or as captured. This opens up possibilities for creative expression that until now have been foreign to photography, and it is for this reason that throughout this book I refer to the ways in which painters have considered and dealt with colour. This is definitely not a recommendation to work in a 'painterly' manner, but rather to approach photography as a colourist.

The techniques for handling colour digitally all require a familiarity with software, in which I include the firmware installed in the camera (you could think of this as embedded software). If you simply want to shoot without having to consider image qualities such as colour, you need no more than the basic version of the camera manufacturer's downloading and browsing software. If you want full colour control, however, the list of software to consider expands greatly. Photoshop has such an established position in image editing that most photographers use it at some stage of the process, but there are alternatives. Camera manufacturers' software continues to develop in sophistication and scope, and there are also independent programs designed to manage all the essential workflow from downloading the images, organizing them, making changes, and beyond.

Then there is specialist software aimed at very specific aspects of digital colour. One important area is camera profiling, used in conjunction with standard colour targets. Monitor calibration and printer profiling. also part of the digital colour workflow, call for specific hardware and software. At first this might seem very daunting, but the principles are relatively straightforward and the software does the hard work. Beyond this, new software is being developed all the time to deal with newly identified issues, such as memory colours, or to take advantage of improving camera or computer power, such as high density range facilities. Keeping up to date with these and evaluating them is now, for better or worse, another part of digital photography. It might seem an inconvenient distraction from the photography itself, but it is unavoidable, becomes easier with practice, and in the end pays dividends.

Colour management

In digital photography, the number of different devices used in the workflow, from camera to monitor to printer, makes it essential to control the colour so that it stays consistent. **Colour management is the process** by which you ensure that the colours you see in the scene in front of the camera are kept as they should be throughout the several stages of capture, editing, and delivery. It is, and is likely to remain, a hot issue in digital photography, because before you can use colour creatively with any degree of subtlety, you need to be

confident that the combination of equipment and software that you are using will deliver exact colours when you need them.

And yet, while digital imaging now provides all the means for controlling colour, colour management was never such an issue in the days of film, which often suffered more from colour shifts and inaccuracies. The key to this seeming inconsistency is that with film there was a physical object to which everyone could refer. Even if the colours in that piece of film were wrong in

Basic workflow

Colour management requires the conversion of all colour descriptions to be converted into an independent colour space. This takes place within the computer.

While cameras and scanners apply their own idiosyncrasies, monitors and printers can also display colours wrongly. The CMS allows for all this, to make the display as close as possible to the original.

some way, and allowing for some differences in the quality of the light box on which it was viewed, it remained tangible. Now, with digital photographs, there is no single reference image, only versions of it that depend on the viewing platform - and computer monitors and the systems on which they operate are hugely variable.

The software used for managing colour is called a Colour Management System (CMS), and for any serious photography is absolutely necessary. Fortunately, colour management is now standard with most good cameras, computers, and imaging software. If you have at least an accurate generic camera profile (normally automatically readable), a calibrated monitor, the right entries in Photoshop's Color Settings, and a calibrated printer profile, your **Render intent**

Some colours will be out of gamut when you change from one colour space to another, and so the colour management system needs your guidance in how to effect the compromise. This is known as render intent, and Photoshop offers four choices.

- With a perceptual intent, the colour space is simply shrunk;
- with a saturation intent the vividness of colours is preserved (more useful for graphics than for photographs);
- absolute colorimetric makes no adjustment to the brightness:
- relative colorimetric changes only those colours that are out of gamut between the two spaces, and is the normal intent for photography.

Document (Prof Proof (Prof			
Options			
Color Handling:	g: Let Printer Determine Colors		
Printer Profile:	Working RGB – sRGB IEC61966		
Rendering Intent:	Relative Colorimetric	😫 🗌 Black	
Proof Setup Preset:	Working CMYK	*	
	Simulate Paper Color	Simulate Black Ink	

colour management is likely to be in good shape.

Colour gamut is the range of colours that a device (camera, monitor, printer, for example) can display. A CMS maps the colours from a device with one particular gamut to another. Typically, the CMS uses a Reference Colour Space that is independent of any device, and a colour engine that converts image values in an out of this space, using information from the 'profile' supplied by each device. So, for example, a CMS converts monitor RGB colours to the smaller gamut of printer CMYK colours by using an intermediate colour space that is larger and device-independent, such as L*a*b*. Thus, it converts from RGB to L*a*b* and then to CMYK, changing some of the colours according to the render intent. This determines the priorities in the process, in which inevitably some need to be altered (see the Render Intent box).

Some cameras allow the user to set the colour mode, for greater control.

Colour space

A colour space is a model, often represented as a three-dimensional solid, for describing colour values, and it has a 'gamut', or range of colours that it is capable of recording or displaying.

Working

colour spaces available in

photography are Adobe RGB (1998), the larger of

the two shown here and

sRGB. The latter is convenient for printing,

but fails to capture as

many greens and reds.

The two most common

The standard colour space for digital photography is RGB, defined naturally enough by the three components red, green and blue. Camera sensors use an RGB filter to distinguish colours and computer monitors display colours by mixing RGB. In practice, there are a number of RGB spaces, including sRGB, Adobe RGB (1998), and Apple RGB, some larger than others and covering slightly different areas of hue. You might

wonder what could be better than the largest colour space possible, and what could be the advantage of a small colour space. The answer lies in the final form in which the photograph will be displayed – as an inkjet print, for example, or as a CMYK repro print in a magazine, or on-screen. The wide gamut of a large colour space can indeed record very many subtleties of colour, but this is no use at all if you can't display them. Colour spaces are matched to different purposes, and the two most widely used are sRGB – small but ideal if you go straight to print from a camera image without image editing – and Adobe RGB (1998), which is wider and better suited to image editing in Photoshop.

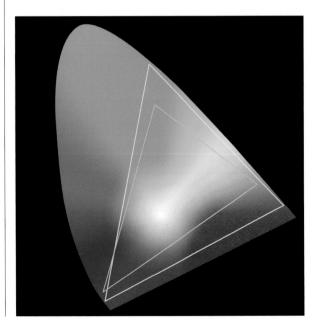

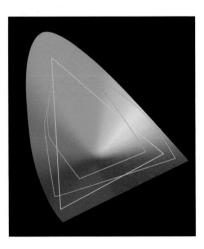

The colour gamuts of a typical 8-bit monitor (white) and typical digital colour print paper (pink) compared (in so far as is possible when printing using CMYK). For comparison, the gamut of an average colour transparency film (blue) is superimposed.

Working with HSB and Lab

Although RGB is standard in photography, it is arguably not the most convenient way of editing images on the computer. HSB controls and Lab mode have much to recommend them.

Image editing programs such as Photoshop offer a choice of controls for adjusting colour, and they go by different names. Some are 'modes' (Lab in Photoshop), while others are adjustment dialogs

(Hue/Saturation... and Replace Color...). Despite this unnecessary confusion in Photoshop, we know that HSB and Lab are both models and can be used to alter colour in ways that are often more useful than regular RGB, which functions as the default mode.

The advantage of HSB is that it is the closest thing we have to an intuitive method. Not surprisingly, it is the model that is accessed by all good colour-correction software. In Photoshop, the two most important controls are Hue/Saturation and Replace Color. iCorrect EditLab Pro 4.6 is a specialist colour software application featured on page 78. Sliders are the usual control mechanism and, valuably, HSB allows colour ranges small to large to be targeted. This makes selective colour control possible from within the dialog box (see page 154 for practical applications of this). Lab also has advantages, although not quite so obvious. Remember that Lab was developed as a very large colour space rather than as a user tool. In fact, Photoshop uses Lab as an internal colour space when making some changes. By separating Lightness as an individual channel, Lab is at its most valuable when you want to make brightness changes with no effect at all on the balance of colours. There are fewer occasions for using the other two, colour channels a* (green-red) and b* (blue-yellow), although if you know that you want to make a shift on either of these two axes, they are very direct.

Large colour spaces do play an important role, but as intermediate spaces for conversion. L*a*b*, developed in 1976 by the Commission Internationale d'Eclairage (CIE, and so this space is also referred to as CIELab), was designed to match human vision as closely as possible in the way we perceive and appreciate colour. It has three parameters, or axes: one for brightness and the other two for opposing colour scales. L* stands for luminance (that is, brightness), a* for a red-green scale and b* for a blue-yellow scale. The logic behind this is that each of the three axes oppose complementaries – dark against light, red against green, and blue against yellow. In human visual perception, red cannot contain green, nor blue contain yellow. Being a large colour space, it is also useful for converting colours from one model to another, as nothing is lost. Indeed, Photoshop uses L*a*b* internally for converting between colour modes, and it is available for image editing. Nevertheless, it is what is called a device-independent colour space.

The other colour space that figures largely in professional photography is CMYK, representing the inks used in printing books, magazines, and the like. The initials stand for the three complementaries of RGB - cyan, magenta, and yellow - and K, meaning key, for black, which is a necessary ink in printing to achieve full density on paper. The CMYK colour space is significantly smaller than others used digitally so, while it is an essential last step for repro, it needs skill and experience to use because colours can be lost in the process of conversion. Most photographers leave CMYK conversion for the printers or client to do.

Sampling in a range

Sampled colours within a colour range: to target a range of hues, use the dropdown menu within Photoshop's Hue/Saturation dialog. To exclude one of these ranges, make an increase overall (that is, on Master) and then make an equally strong decrease to the colour you want to stay as is. For more precise targeting, having selected a hue range as above, then click on the exact colour in the image. The hue selection sliders at the bottom of the dialog box will change slightly, and you can close them up for even more precision.

Calibrating monitors

The monitor screen is where all the important decisions about digital colour are made, and the procedure for making sure that it accurately represents colours is calibration, an essential first step. As supplied with the computer and without adjustment, the monitor display will give you a reasonable accuracy of colour - usually. For professional or creative colour adjustment, however, an unknown level of reasonable is not good enough. Moreover, calibration to an adequate degree is easy, and often provided at system level by your computer (if not, consider another computer!). At the very least, you want to be sure that you are displaying neutral greys as truly

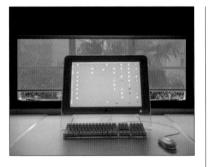

An ideal lighting environment, with soft daylight from behind the monitor (to cut down on reflections). neutral, not only for the mid-tones but also for the blacks and whites.

Before all else, make sure that the viewing conditions are good. Simply put, this means that the ambient light level in the room should be at least half of the brightness of the screen (black is better, but tiring on the eyes) and that the surroundings of wall, desk, and so on are neutral, not coloured. Needless to say, the screen desktop should be a simple neutral grey, not a photograph of the family or the dog.

Monitor calibration is the starting point for colour management, and there are two basic methods: by eye and with a measuring device. The eyeball method is not bad at all, and is available at system level on modern Windows and Mac operating systems, via a set-up assistant. The sequence prompts you to adjust by eye the brightness and neutrality of the black, white and mid-points, also the gamma (see box for definition) and the colour temperature. You then save the results as a monitor profile.

A colorimeter is

and create a profile for it. Simply place it on your screen and the software supplied will cycle through some colours and create a profile.

66

More accurate is hardware calibration, using either a colourimeter or a spectrophotometer placed on the screen to measure the actual display. These devices come with software that runs a program of colour variations, at the end of which a monitor profile is automatically created. The sequence shown here is that followed by OptiCal software, using a Spyder colourimeter. The resulting profile is then saved as standard.

Gamma

The angle of slope of the response of a monitor to a signal is known as gamma – technically a plot of the intensity of the output signal relative to the input. The standard gamma for Windows is 2.2, which is higher (so darker and more contrasty) than the standard for Macs, which is 1.8. This means that photographs that look good on a Mac will look darker and more contrasty when seen on a Windows computer screen.

🛚 Gamma

These images show the result of viewing images on alternate systems. The above was saved in Windows gamma as viewed on a Mac, the right-hand one created on a Mac and viewed on a PC.

In-camera colour

The starting point for colour correction is the camera itself, which contains setting options in its menu for white balance and, in some models, hue adjustment.

360° hues

Spectral hues are conventionally given angles according to their position on the circle, with red as 0º/360º. Some cameras have separate hue adjustment control, allowing you to shift hues around the spectrum by degree. In the physical world - without digital adjustment - hues change only with differences in the colour of light. 0/360° 315° 45° 270°-- 90° 135° 225° 180°

The camera menu offers a number of controls

for getting close to an accurate colour, and the one that receives most attention is the white balance. The principle of this is that by setting the whitest part of a scene to neutral, you will in effect have adjusted the sensor to the light source. As we saw on page 24, the colour of lighting varies greatly. This is no problem for

the sensor, provided that it is given some help. The menu contains several precalculated settings for sunlight, cloud, shade under an open sky, and fluorescent lamps. These will usually get close to an accurate balance. There is also an auto white balance setting which will calculate the colour balance from its analysis of bright tones in the scene. High-end cameras have a further option, called preset, in which you aim the camera at a white or grey card in the lighting that you will be using for a session; the camera then sets this as neutral.

Higher-end digital cameras offer a choice of image formats that includes, in addition to the normal TIFF and JPEG, the Raw file. Actually, each manufacturer's Raw format is unique and tailored to the design of sensor and the camera's imaging engine. What they all have in common is that the data collected by the sensor is kept separate from the settings (which include exposure, contrast, and white balance, among others), so that it can be accessed later. Also the original high bit depth is maintained, and in a highend camera this is likely to be 12 bits per channel (4096 rather than 256 shades per channel). Image editing software like Photoshop, capable of editing up to 16-bits per pixel, can take advantage of all this data, uses this difference to give the typical Raw file an exposure latitude of four stops.

Raw converter software

In order to be able to make use of Raw format's considerable advantages, you need specific software that can access the data from the camera and can work in at least 12 bits per channel. The camera

manufacturer's own image editing software contains this, as do the newer versions of Photoshop. In addition, third-party workflow software, of which the best known is Phase One's C1 Pro. also has this ability.

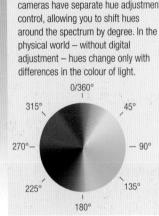

Bit depth and colour

Bit depth is the number of discrete levels of tone that can be recorded and stored, and in many ways is the key to full colour control in digital photography. It is sometimes referred to by channel, sometimes by all three RGB channels together. The standard bit depth, and the only one for display on a monitor screen, is 8 bits per channel, or 24 bits overall. Image files, however, can contain more data (16-bits-per-channel is supported by Photoshop), which even if not seen onscreen - provides much more latitude in editing. Up to 281 trillion colours instead of the 16.7 million in an 8-bits per channel image.

Practically speaking, you can recover up to two stops of exposure either way; the upper limit is set by the image's highlights. Once a pixel has reached its maximum brightness value nothing can be recovered from it.

The advantage of Raw

For fine colour control, nothing beats the Raw format available as an option in better digital cameras. It allows you to revisit the original settings with no loss of quality. You can, in effect, defer the delicate decisions about colour until later,

Recovering exposure

Colour, as we see on page 82, is strongly affected by exposure, which is in any case a primary technical concern of photography. Raw format, properly exposed, is the silver bullet for exposure difficulties. Raw converter software (either supplied with your camera, bought separately, or the converter built into Photoshop) allows you to revisit the occasion of shooting and choose a different exposure setting of up to two *f*-stops in either direction. However, this magical 4-stop exposure latitude has an important limit – you must expose for the highlights. Once a pixel has been exposed up to 255, or even a couple of levels below, the colour values have been irrecoverably lost.

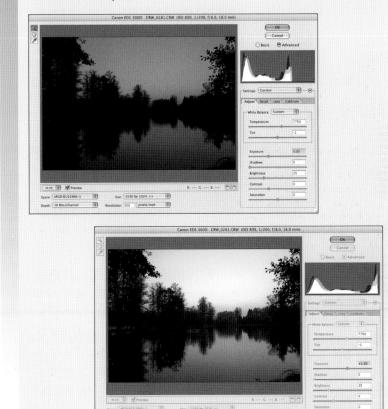

Resolution 300 [pixels/inch 1]

when you have more time to consider the editing, and you can be confident that as long as you have captured the maximum amount of information in the camera, and have avoided clipping the highlights, you will be able to adjust any and all of the colours as much as you like. This only works, of course, if you are prepared to spend the extra time involved converting and editing the Raw images. Many photographers simply want to get the shots in and out of the camera with as little fuss as possible.

Camera profiles

In the same way that a monitor can be profiled by calibration, the unique characteristics of your camera's sensor can also be measured and used to colour-correct images. The ultimate check for the colour of light is a standard target that you can carry with you and use to shoot test frames. These vary from a simple neutral grey to customized, and expensive, colour mosaics. The most widely used is the GretagMacbeth ColorChecker, which uses special, and accurately-printed, Munsell colours (see page 14). Another useful reference target is a standard Grey Card. Both of these are widely used and

are known quantities, so that shooting a first reference frame of one of these targets makes it possible to balance the colours later.

While the very simplest way of using them is as a basic eyeball check when you open up the digital files in a browser or image-editing program, the

Shooting the target

- 1 Place it square-on to the camera.
- 2 Make sure the lighting across the chart is even.
- **3** Use low sensitivity and meter as average.
- 4 Set the exposure so that there is no clipping of highlights or shadows.
- **5** For making a camera profile, follow the software instructions.
- 6 Evaluate in image editing (see page 72).

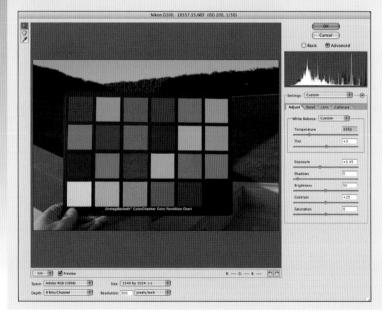

most accurate way of using them is to create an ICC profile. These profiles (ICC stands for International Color Consortium) are the basis of colour management systems, and are small files that can be accessed at system level by the computer. A program such as inCamera by PictoColor, used as a Photoshop plug-in, can read the photograph of the chart that you shot, compare it with the known values, and construct a small file known as a camera profile that will instruct Photoshop to make the necessary adjustment for any image that you choose. Simple and highly effective, but a camera profile will be accurate only for that exact lighting, which makes it more useful for controlled studio or indoor conditions than general shooting.

GretagMacbeth ColorChecker

A 24-patch mosaic of very accurately printed colours, including neutrals and 'real-life' colours such as flesh tones, sky blues, and vegetation. This is the standard colour target for photography, though relatively costly because of the special printing. Even more expensive is the GretagMacbeth ColorChecker DC, which has many more colour patches. Because the colours are printed matt, the range from 'white' to 'black' is quite short, and the 'black' is really a dark grey. One precaution when making a profile is to make sure that the white and black are close to the recommended values below.

Grey Card

Not for making a camera profile, but still very useful for guaranteeing the basic neutrality in an image, is an 18% reflectance grey card. In a digital image it should measure 50% brightness and R128, G128, B128. The reason for 18% as a mid-tone is the non-linear response of the eye to brightness.

Assigning profiles

When you open images shot under these same lighting conditions, assign the profile that you saved. In Photoshop click *Image* > *Mode* > *Assign Profile*, then straight away go to *Image* > *Mode* > *Convert to Profile* and choose your normal working profile (which will probably be Adobe RGB (1998). Finally, you may need to tweak the result, particularly for contrast. Profiled images tend to be a little flat, and a gentle contrastincreasing S-curve in Curves often improves the image.

Creating the profile

- Open the image in Photoshop. If the warning dialog reads 'Embedded Profile Mismatch', choose 'Discard the embedded profile (don't color manage)'. If the warning dialog reads 'Missing Profile', choose 'Leave as is (don't color manage)'.
- Check that the greyscale values are as recommended above. Adjust Levels and/or Curves to bring them into line.
- 3 Launch the profiling filter.
- Choose the appropriate target, and its reference file:
- Align the grid by dragging the corners.
- Let the software construct the profile, then save it where other profiles are stored on your computer.

A question of accuracy

Ultimately, colours in photography are judged by eye, not by machine, which means that accuracy involves both measurement and perception. **The tools for colour control** that we've been looking at operate on the premise that there is such a thing as perfect colour correction - that for every photograph there exists one accurate version. Inevitably this leaves aside individual interpretation, but how reasonable an assumption is that to make? In some

cases it is fair, but these are remarkably few and tend to be limited to specialist reproduction of pack shots and artifacts such as textiles, paintings, natural history and other scientific specimens, and the like. For most photography the criteria are different.

We assume we know when the colours in an image are correct, which is to say as they should be. In reality, most people hardly think about it at all, and the question arises only when a colour appears to be seriously wrong. If, for instance, sunlight falling on a surface appeared to have a tinge of green, we would 'know' immediately that that shouldn't be so. And how do we know that? By experience, which, if you think about it, is not a very good basis for judging how any of the several million colours that we can recognize should be, and certainly not easily comparable with the scientific approach.

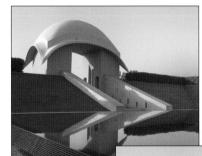

Accurate In this example, the ColorChecker is used as a guarantee of accuracy, after the shot has been taken. The profile makes no allowance for the 'warmth' of the

afternoon sun.

By eye In a case like this, if you want to add warmth, you will have to lower the colour temperature by eye after assigning the profile.

As shot The scene, a new hotel in India, as shot with a Sunlight white balance. At the same time a ColorChecker was shot

72

Nevertheless, as eye judgment by someone is the final arbiter, it has to be factored in to the equation. Unless you go to the trouble of making a camera profile, which for reasons already explained (see page 70) is not normally practical, then all the other tools for colour control require some opinion or prior knowledge of what a color should be. This applies equally to choosing a neutral in a photograph, a memory colour such as skin tones or sky, or even the quality of light, from cloudy, through shaded, to incandescent. As we saw, there is a wide latitude built into all of these. and this latitude allows for choice. Camera profiling is as close as you can get to verifiable accuracy, yet even it has limitations. Even though a camera profile for one specific

lighting situation will guarantee that the colours measure correctly, this is still not a solution that accounts for all factors, since it ignores perceptual accuracy. The obvious case, though by no means the only one, is when the sun is low and the colour temperature is lower than midday 'white'. If you diligently use a colour target in the manner described on page 70, or even if you simply photograph a grey card and use that to set the neutral grey balance of the images, the results will be measurably correct but will look wrong. Quite apart from any subjective feelings that you may have about early morning and late afternoon light - the attractiveness or otherwise of a scene bathed in golden light, for example - we expect this kind of situation to look warm.

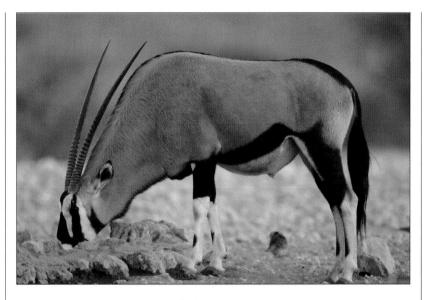

As shot The Oryx, as photographed with a Daylight White Balance.

By eye A more complex exercise in judgment. This Orvx was photographed from a hide at sunset in Namibia, with no opportunity to shoot a grey card. To get the colour of the near-neutral accurate is a problem a tracker, guide, or professional hunter is best placed to solve, and their opinions were canvassed the next day. The practical issue boils down to finding the neutral point on the animal and, as three interpretations show. where you sample makes a difference. In fact, as the professional opinion had it, and shown by a midday shot taken on the following day, the most reliable neutral is on the rump (middle).

Memory colours

One of the most valuable methods of evaluating overall colour accuracy, though it needs to be used with caution, is to focus on the colours of things with which we are so familiar that we know innately how they should appear. Certain kinds of colour are more fixed in our minds than others, meaning that we have finer discrimination and stronger opinions about whether they are accurate or not. To an extent this varies from person to person, and depends on particular interests, but there are a few standard sets that most of us recognize. They are known as memory colours because they seem to be embedded in our visual memory. Naturally, they play an important role in image editing because they are an immediate key to assessing the

Skin

In the same way that we are highly sensitive to all aspects of the human body (for instance, face recognition), we have an innate judgment of the colour of skin, which has to fall within an expected range. Note, though, the differences here even between two pale Caucasians.

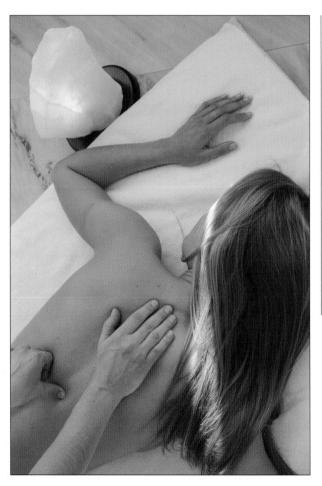

colour accuracy of a photograph. For memory colours we can most easily say whether they are 'right' or 'wrong', and to what degree, and we can do this intuitively. Measurement is important in optimization, as we saw, but as colour is ultimately a matter of perception, never underestimate the importance of subjective judgment. If it looks right, it is right.

The two most important memory colours are those with which we have most familiarity: neutrals and skin tones. Following this, there are green vegetation and

Neutrals

Objects and surfaces in a photograph that should be neutral include concrete, steel, aluminium, car tyres, asphalt, white paint, black paint, mid-day clouds.

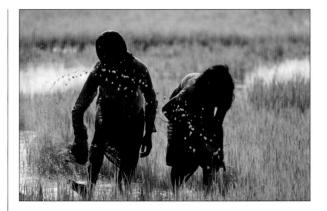

Grass

Plant life is another memory colour, although the range of acceptable areens is wider than for most other colours.

Concrete and makes a good

Urban concrete in its many forms is taken by the eye as a neutral, reference for adjusting digital images in postproduction.

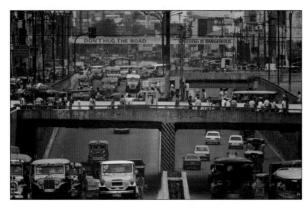

sky tones. It also depends on the environment in which you grow up - if you live in New Mexico or North Africa, you will be more attuned to the colours of sand and rock than if you live in northwest Europe. Adjusting the memory colours in a photograph involves matching them to known samples. At its simplest, this means relying on your memory at the time of correction, but you can refine the process by referring to samples that you already accept

as accurate. One way is to open a second image that is already welladjusted and use it for reference. Another is to build a set of colour patches that represent memory colours that are correct for you. There is also software that deals specifically with memory colours. The adjustment approach is basically that of source and target.

Memory Colors-Memory Colors Memory Colors Memory Colors Sky -Neutrals -Skin -Foliage Name: Neutrals Name: Sky Name: Skin Name: Foliage 🕘 Hue: O Hue: Hue 120 Hue: 258 Ο ΔHue ΔHue Ο ΔHue: Ω ΔHue: Chroma 40 O Chroma 32 Chroma: 40 Chroma: Picker. Picker. Import. Picker Picker. Import. Import. Import... Load. Save Save. Save. Load Load... Save... Load. Clear Clear Clear Clear

Dedicated software

iCorrect Professional stores a range of memory colours that includes neutrals, skin, foliage, and sky, and also allows users to create their own. The range of colour for each of these is defined by three parameters: Hue as an angle between 0 and 359 degrees on the international CIE colour circle (not Photoshop's HSB system).

Chroma A percentage that defines the saturation, also using CIE standards, not Photoshop's HSB.

 Δ Hue A value between 10 and -10 that controls the way that the hue changes between dark and light tones. If zero, there is no change from light to dark. If negative, the hue angle decreases as lightness increases. If positive, the hue angle increases as lightness increases

Personal colours

The key to the success of the GretagMacbeth ColorChecker is that it contains 'real-life' colours. But each photographer has preferences and a range of colours that have a particular relevance. While specialist printing, in the way that the ColorChecker is produced, is out of the question, it can be useful to create colour patches that are closely tailored to your own experience and preferences. If you have a feeling for colour, then you are probably attracted to certain kinds of colour. Equally, if you spend most of the time with a camera photographing a particular range of subjects (such as flowers, people or buildings), or in a

specific location (be it the Arizona desert, the Florida Everglades, or the English countryside), then you will automatically be working with a special selection of colours.

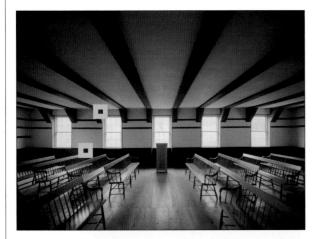

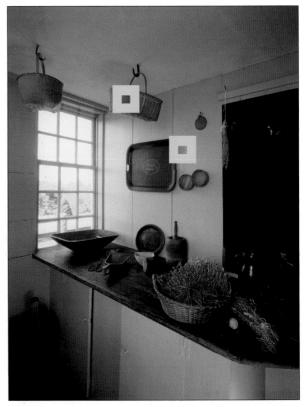

This makes a useful project for two reasons. One is that you will have, at the end of it, a worked-out reference for specific colours that you want to get right – and get right consistently. The other is that it helps to exercise powers of analysis, and encourages the identification of which colours you come across the most often. In Photoshop, make a grid of about 20 squares, as shown here, and then fill each of these with a colour that is relevant to your particular photography. One aid to this is a review of your own photographs, using the browser, and then sampling specific colours. To do this, open any image, click on the Eyedropper tool in the toolbox, then click with it on the colour you want. Go to the blank colour chart and, using the Magic Wand tool,

click on a blank square to select it, then fill with the chosen colour. Now go to *Edit > Fill* and choose Foreground Color. Alternatively, use the Color Picker to create a colour that you want.

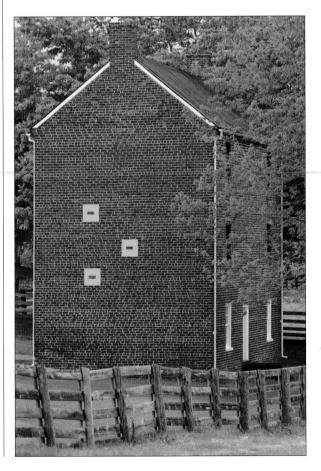

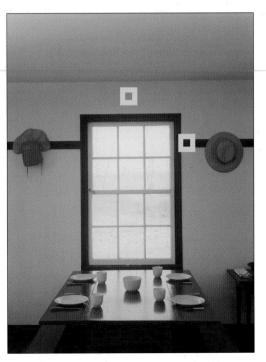

77

Black point, white point

The most basic, simple and effective technique for bringing the colours and tones of a digital image to their optimum is to find the darkest and lightest points and make them firmly black and white respectively. **The process known as optimization** is designed to make an image appear at its best by making the fullest use of the gamut of the monitor and printer. The first step is to spread the range of tones and colours captured as widely as possible over the 8-bit scale from black (O) to white (255). This is known as setting the black point and white point, and there is a choice of techniques. In Photoshop, the starting point is Levels. There are three sliders below the histogram, one each

for black point (left), white point (right) and mid-point (centre). Drag the black-point slider in from the left until it reaches the first group of pixels in the histogram. These are the darkest pixels in the image, and doing this will make them black. Then do the equivalent with the white-point slider. Click OK. To check the result, reopen the Levels dialog and you will now see that the

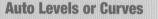

An alternative to these hand-tuning procedures is to take advantage of automated optimization. In Photoshop, there are the following, available under Options... in the Curves dialog box:-

- Enhance Monochromatic Contrast The same as the Auto Contrast command. Brightens highlights and darkens shadows while maintaining colour relationships.
- Enhance Per Channel Contrast The same as the Auto Levels command. Maximizes the tonal range in each channel, and so quite dramatically, with colour shifts likely.
- Find Dark & Light Colours The same as the Auto Color command. Maximizes contrast while minimizing clipping by searching for the average lightest and darkest pixels.
- Select Snap Neutral Midtones
 Finds the colour closest to neutral in an image, and then adjusts the gamma to make it exactly neutral.

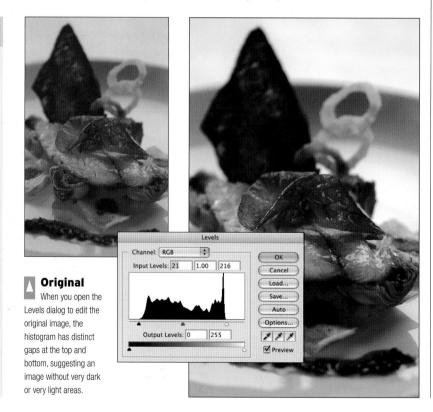

histogram has been stretched to fill the full scale. A useful check when doing this is to hold down the Alt/Option key as you drag the sliders. With the blackpoint slider the image on screen will be pure white until you reach the first pixels - it will indicate at what point you begin to clip the shadows. With the white-point slider the same key has a similar effect, except that the base colour on screen is black.

An alternative method is to use the black-point and white-point droppers to the bottom right of the dialog. First, click on the black-point dropper, then find the darkest shadow in the image and click on it. Follow this by clicking on the white-point dropper, then find the brightest highlight in the image and click on that. To find the darkest shadow and brightest highlight, either use the technique just described, or else run the cursor over the image while looking at the results in the Info palette.

Once black and white have been set in an image, the next step is to establish those tones that you think should be grey as perfectly neutral. The most direct method is to find a point in the image which you know should be neutral, or which you would like to be neutral, and then click on it with the grey-point dropper. Having first found an area that should be neutral, run the cursor over it and watch the Info palette to see if the RGB values are equal.

Setting target blacks

Printers fall short in their ability to reproduce true blacks and whites. Set the black and white points to somewhat less than the extremes by double clicking the black-point and white-point droppers and entering new figures. Reasonable settings are 10,10,10 in RGB for black and 243,243,243 in RGB for white.

iCorrect EditLab Pro

This specialist colour software uses a four-step approach in a logical sequence. It also has an automatic feature called SmartColor:

- Colour balance, to remove global colour casts. This is done by clicking on neutral objects in the image or by moving sliders. Result: colour balance fixed
- Black point and white point selection, to alter the range of the tones usually stretching it to fit the scale. Result: range fixed
- Global brightness, contrast and saturation controls, to redistribute the tone values between black and white, and between neutral and fully saturated colours. Result: tone distribution fixed

 Hue-selective editing, to alter brightness, saturation and hue – yet constrained to user-defined hue regions. Corrects nonneutral colours. Result: individual colours fixed

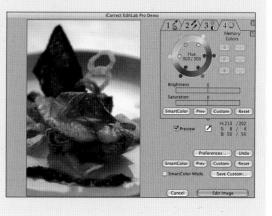

Colour and contrast

Contrast is not simply an issue of exposure and tonal range. It affects the intensity of colours, and the problem with high contrast scenes is to hold colour values.

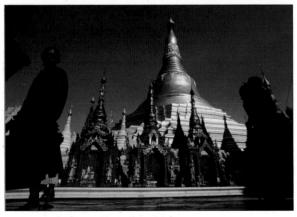

High contrast

These two very different images both show a diverse, and contrasty, range of colours. In the upper image, the dark trees stand out against the bright yellow, while in the lower image the red and gold buildings stand out from the darker sky. **Exposure is a matter of colour.** Too little will produce dark and muddy hues, while too much will bleach them out. It is common to think of colour as a matter of hue and saturation, with brightness as a separate issue, but this is wrong. In photography, as in nature, colour is defined by three qualities - hue, saturation and brightness - and the last of these depends on the exposure setting. Colour, therefore, is dependent on the range of contrast in the scene.

High contrast has always been a problem in photography, because the dynamic range of the materials – whether film, sensor, or paper – is just nowhere near as high as the eye's ability to distinguish tones. Digital sensors have a special problem in that their response to quantity of light is linear. The individual photo-sites fill up in proportion to the light falling on them. Crudely put, most digital camera sensors overexpose easily.

This apart, digital photography does have solutions. Provided that the pixels captured do have some recorded value - that is, a few levels above 0 and few below 255 - they can be restored and enriched if wanted. The traditional advice for slide film works well for digital: expose for the bright colours and let the shadows go. This is fine up to a point, if the shadow areas are small or will work well as silhouettes but, if not, there are two valuable techniques that can restore the colour values across a wide range of shadows and highlights. One is to shoot Raw, which automatically gives you an exposure latitude of up to four f-stops in post-production. The other is bracketing: to shoot at least two versions of the same image, one with a lower and the other with a higher exposure so that you capture highlight detail in one and shadow detail in the other. For this second

Ideal exposure

For any hue at a given saturation, there is an exposure that will render the strongest colour. With different colours in the photograph, the choice of exposure will typically favour one or the other, not all.

technique, the camera (and subject) mustn't move between shots.

With the Raw image, the software can optimize the colours more efficiently than would be possible with an ordinary 8-bit TIFF or JPEG. It can even be used to create two versions of the same image - one at minimum exposure, the other at maximum - which can be used in tone mapping.

However you got the separate images, the next step is to blend them in such a way that the best shadow and highlight detail is

preserved in the final image. The most primitive approach to this, though still effective, is to paste one on top of the other as a layer in Photoshop and use the Eraser tool to remove the less well exposed areas. Another is to make either a highlight mask or a shadow mask, apply this as a selection to the upper layer, and delete. A third is to adjust the curves and choose an

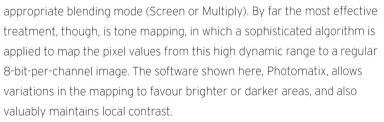

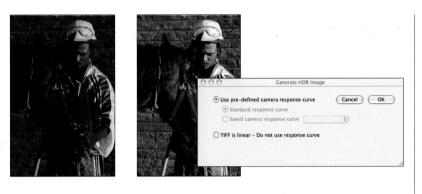

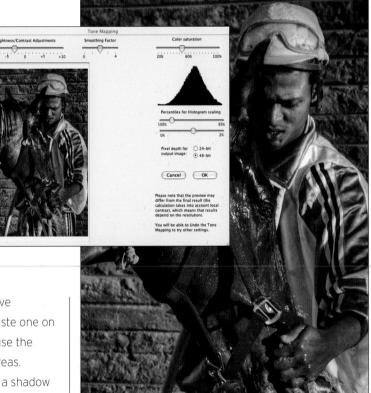

Tone mapping

The sophisticated digital approach to high contrast is to map the colour information from a 16-bits per channel, or High Dynamic Range (HDR), image into a normal, viewable regular 8-bit-per-channel image. The algorithms are more complex than simply squeezing the range of values, but the result is to include the best of the shadow detail and the best of the highlights.

81

The subjective component

So much effort is spent in ensuring colour fidelity that it's easy to ignore personal taste and preference. But your work should express a visual idea as much as get things 'right'. **Colour management** has reached the point of being an obsession for many digital photographers because the technology is relatively new and calls for attention. The different hardware (including the camera) and software need coordination, and this is what makes colour management essential, but the reality is that to handle colour well, as a colourist, you must have an

opinion about it. Getting colour under measurable control is a first and important step. Making your own colour statement is the next.

One of the clearest examples of the validity of subjective opinion in colour is in the choice of saturation. As we've seen, HSB is the most comfortable, rational way to adjust colour, yet psychologically we attach different weight to these three parameters – hue, saturation and brightness. Hue is generally considered the essence of colour. Brightness tends to be thought of,

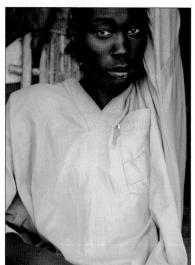

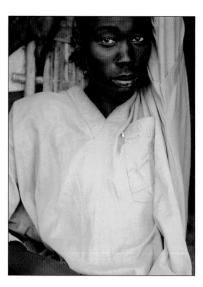

WORKING DIGITALLY

particularly by photographers, as being tied more to exposure and tone than to hue, leaving saturation as the principal modulator - at least in most people's judgement.

The point that I'm making here is that there is a more readily accepted creative latitude in saturation than in other colour parameters, and we certainly see evidence for this in colour repro for books, magazines, postcards, and the like, where it is frequently altered in the production process.

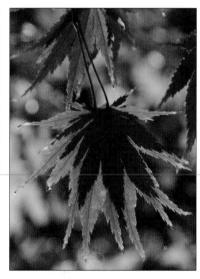

As an experiment, here are two images offered at different saturations. To get full value from the case study, first decide, after studying the choices, which you prefer. Then cover up all the other versions and let your eye accommodate for a few minutes to this one. Even come back to it after a break. Then uncover the other images. Has your perception and judgment changed? Finally, what is the range of saturation that you personally find acceptable? The exercise is even more valuable with one of your own images. The lesson, of course, is that there is indeed a range, not a single point of acceptability. Tobacconist A Dinka tobacco seller in a market

town in Sudan. This is an image about colour, in particular the relationship between a particular yellow set and very dark skin. (Anticlockwise from centre: saturation +11, as shot, +11, +22, +33.)

Leaf

A more obviously colourful image than the portrait, with some obvious tendency towards richness and full saturation. Increasing saturation strongly is a temptation. (Clockwise: saturation +33, +22, +11, as shot, -11.)

Printer profiling

The third and final piece of equipment in most photographers' workflow is a printer, and this too needs an accurate profile, which can be properly done only with professional calibration.

Spectrolino GretagMacbeth Spectrolino (or Spectroscan) is a precise colour measurement device for analyzing output from your printer.

Maker Profile-building software is used to measure the results from the Spectrolino scanner and create a new colour profile for the device.

Profile

Profiling, whether applied to cameras, monitors, scanners, or printers, is the way to guarantee colour accuracy, and is the basis of a sound colour management system. With printers there is a little more work to do, some of it professional - but the results are always worth it - you can then have total confidence that what you see on the screen will be very close to what you get as a print. The professional component to this is the measurement of a colour target, which really needs a spectrophotometer to be accurate. You can expect to pay for this service.

With cameras, as we saw, profiling is useful only when the lighting conditions are precisely the same for target and shooting, as in a studio. With printers it is not only essential, but also predictable. As long as you stick

ProfileMaker 5.0	
MONITOR CAMERA SCANNER	PRINTER MULTICOLOR DEVICE LINK
Reference Data TC9.18 RGB.txt	Profile Size Default : Perceptual Rendering Intent Paper-colored Gray : Gamut Mapping LOGO Classic : Separation
Measurement Data (sRGB.icc)	Viewing Light Source
	Calculate Profile Start Batch

to a known set of papers and inks, the profiles you use will always produce the same results. Printers make colours in a completely different way from digital cameras and monitors. They use process colours (cyan, magenta, and yellow, plus other inks such as black, grey and light magenta) and the image is reflective rather than transmissive. The implication of this is that a spectrophotometer is needed to measure the pigments, and this is expensive and calls for skill in operating it. As a result, printer profiling is normally offered as a service. You could, of course, stick

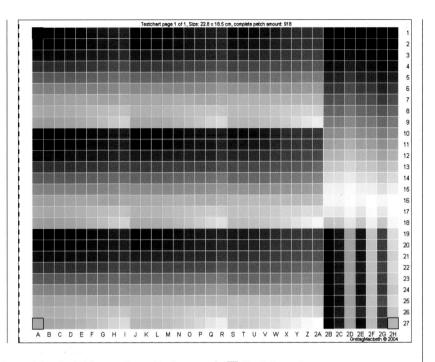

with the generic profile supplied with the printer, but this may be quite far from the way it performs with the papers you choose.

There is now a wide variety of paper and inksets for inkjet printers, and it is worth experimenting to take full advantage of these. Having decided on which to use, the normal procedure is to print out a digital test target supplied by the profiling service. You then return this to be measured accurately and have an ICC profile created – as with camera profiles, this corrects for the difference between the way your printed image looks and

the way it should look. You then load this profile into your computer and use it whenever you print. In practice, there would be one profile per paper/ink combination.

Test target

The TC9.18 target was designed by colour guru Bill Atkinson. Its 918 patches provide a great deal of information for the software and works equally well on pigment or dye-based printers using 4 (or more) inks.

Printing

The first step in creating a colour profile is to print a test target, such as the TC9.18 above. You should print a different test target (and create a different profile) for each different kind of paper you plan to use.

Real Life, Real Colours

Having looked at the basics of colour in chapter one and at the digital techniques for adjusting it in chapter two, we can now turn to how colour appears in the world in before the camera. With all the possibilities for tuning, enhancing, and even creating colour that digital photography and image editing offer, we must always start with the colours of real objects in real scenes.

The values and associations of individual colours are complicated immensely as soon as they are seen in the context of other colours. Yellow seen against blue is not the same as yellow seen against green, and it is in the subtle intricacies of colour interaction and colour relationships that photographs can acquire the power to attract, intrigue, challenge. As in so much else related to colour, the dynamics of these relationships operate at different levels of perception and psychology. There are optical effects generated by the retina, others created deeper in the visual cortex, while overlaid on these are all kinds of acquired likes and dislikes. One of the most vexed areas of colour discussion is that of harmony and discord – colours that are considered to fit well together, to complement each other, versus those that breach an assumed code of approval. This is about taste, fashion, and acceptability, and is ammunition for colourists, whether painters or photographers, to make images that please or displease.

The majority of art, with photography more complicit than most other forms, has been in the service of attractiveness, and this is no surprise. Nevertheless, photography has purposes other than showing things at their most pleasant, and managing colour relationships can be a part of this. Another feature of colours as they are found in life, especially in the natural world, is that they inhabit a more subtle, less pure space than the primaries and secondaries that we saw in chapter one. Differences of hue are much less extreme in the colour circles and swatches available in Photoshop. Earth colours, the complex range of plant-life greens, pastels, and metallic colours all have their own special beauty, less insistent and more finely shaded.

Colour relationships

Colours are never seen totally in isolation, and two different colours side by side will each react to the presence of the other. Ultimately, this is a matter of contrast of one kind or another. **Even when describing single colours alone,** it is impossible to avoid their settings, as we have seen in chapter one. The energy of any hue changes significantly as it moves from a one background to another - as from white to black, for example. This happens in two ways: the characteristics of each colour are altered, and the combination itself creates visual and expressive effects. Our perception of colours changes according to their context.

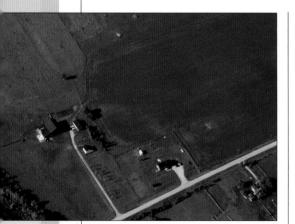

Contrast of hue These farm roofs contrast clearly with the surrounding fields – a good example of contrast of hue, accenting the picture. Ultimately, despite the inherent qualities of a hue, the total effect is determined by contrast. Contrast - and I draw here heavily on the teaching of Johannes Itten at the Bauhaus - is at the heart of design. We can be specific about this, and identify several different types of colour contrast, which we will cover in detail in this chapter. For now, the principal colour contrasts are:

Contrast of hue

That is, combinations of the hues that have been individually described on pages 32-51, and their relationships across the colour circle.

Contrast of brightness

Even though each colour can be dark or light within a certain range, the standard pure versions vary between hues, from violet at one extreme to yellow at the other.

Contrast of saturation

As we have already seen, colours can be adulterated from pure all the way to grey. Usually, the contrast of a diluted colour with a pure hue benefits the former; it gains life from the pure colour, which itself loses energy.

Contrast of sensation

There is a sensory association between colour and temperature, humidity, and even time of day.

Spatial contrast

As seems logical, the bigger the area of a colour, the more dominant it is. Nevertheless, the contrast effects of size are more interesting when a strong colour appears very small. It seems to fight more for attention, drawing the eye to it as a focus of interest. The position in the frame of the areas of colour, and their shapes, also influence the nature of spatial contrast.

REAL LIFE, REAL COLOURS

89

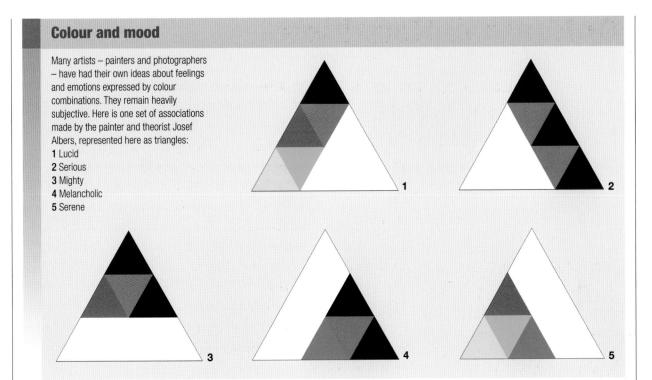

The following pages will be devoted to exploring the great variety of colour relationships, and they extend from the perceptual through to the psychological. Some of the perceptual relationships can be tested and measured, which puts them on relatively safe ground. The psychological effects are another matter. Colour combinations and relationships clearly do affect mood and aesthetic response, but no-one has yet devised a way of quantifying this. As a result, pronouncements by painters, colour theorists, and photographers have always been highly subjective, and inevitably contradictory.

Central to this is the idea of harmony and discord in colour, which relies on the assumption that there is a kind of right and wrong. Not everyone agrees on this, but those who do tend to be dogmatic. There is a perceptual argument, based on successive and simultaneous contrast, as described on the following pages. How far you are prepared to take this is an open question. Harmony is widely, but wrongly, thought of as a description of similarity, arrived at subjectively on the grounds of appearing to be pleasing. In fact, harmony is a function of balance and equilibrium, which can include similarity but is more likely to be based on a particular contrast.

Optical colour effects

There are several important ways in which colours interact that, because of the psychology of perception, are not as most people would expect. There is a set of phenomena that has to do with the way we process colour in the visual cortex, and they have an important bearing on theories of harmony and discord – and so on the ways in which you can present colours in a photograph. The two most important of these are successive and simultaneous

contrast, first identified by the French chemist Michel Eugène Chevreul in the 1820s. Successive contrast, also known as after-image, causes the eye to 'see' the opposite hue immediately after looking at a strong colour. Stare at the red circle for about a minute, focusing on the small cross in the middle. Then quickly shift your gaze to the cross in the centre of the blank white square. You should be able to 'see' a circle of a different colour – blue-green (the same effect occurs if, after looking at the red, you close your eyes tightly). This after-image is a reaction generated by the eye and brain, the effect is strongest with a bright colour and when you have stared at it for a long time. The significance of successive contrast is that the after-image colours are always complementary, meaning directly opposite on the spectral colour circle (as introduced on page 13).

Applying the vibration effect to a natural pattern, the dark stripes of a zebra have been given a gradient of primary colours. If the white spaces were to be lowered in brightness, to a grey, the optical flicker would be even greater.

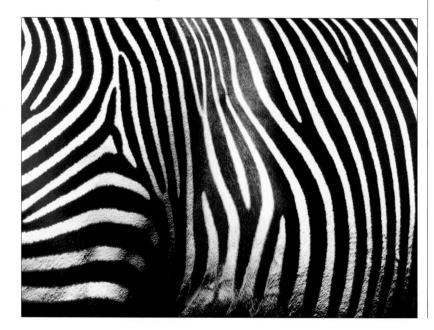

The companion effect to successive contrast is simultaneous contrast, in which one colour, juxtaposed with another, appears slightly tinged with the complementary of the second. This is at its most obvious when a neutral appears alongside a strong, pure hue, as seen in the illustrations and

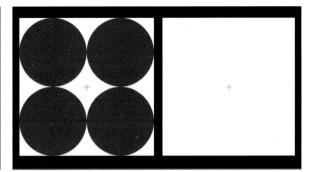

the photographs (page 93). In other words, a patch of grey on a background of a single hue appears tinged with the opposite colour. Although much slighter, this same contrast occurs between two noncomplementary colours; each seems tinged just a little with the opposite.

Circles effect

A variation of this effect includes the white ground. Stare as before at the cross in the left box. After at least half a minute shift to the right cross.

Simultaneous contrast

One of the most well-known and important optical effects, in which the eye tends to compensate for a strong colour by 'seeing' its complementary opposite in adjoining areas. The classic demonstration is a neutral grey area enclosed by a strong colour. The grey appears to take on a cast that is opposite in hue to that of the surround. Grey surrounded by green takes on a slight magenta cast; grey surrounded by red tends towards cyan. The phenomenon also affects nonneutral areas of colour, as the violet and purple pair illustrates. The central squares are identical.

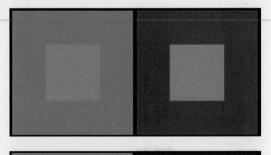

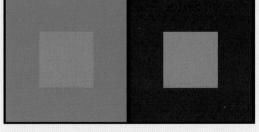

Successive contrast

This effect is similar to simultaneous contrast in principle, but over a (short) period of time. That is to say, the eye reacts to the stimulus of a strong colour by creating its complementary, but does so after exposure. Stare at the cross in the centre of the red circle for at least half a minute, then immediately shift your gaze to the cross in the centre of the white space to the side. You will see an after image that gradually fades – and the colour is cyan. If the circle were green (you can try this for yourself by making one in Photoshop) the after-image would be magenta.

Bezold effect

A colour illusion related to simultaneous contrast, but with an opposite effect, was identified by a German meteorologist Wilhelm von Bezold, and is a kind of colour assimilation. In this, demonstrated by the colour theoretician Josef Albers with a redbrick pair of images similar to the photograph here, the presence of a light colour (white mortar) appears to lighten the red of the bricks when compared with the darkening effect of black mortar. It is as if there is an optical blending taking place.

Purkinje shift

Named after the Bohemian physiologist who described this phenomenon in 1825, this effect occurs at dusk, when the eye's scotopic system (light-insensitive rods) begins to operate yet there is still enough light for the colour-sensitive cones in the photopic system to work. The photopic system is more sensitive to longer wavelengths (reds and yellows) while the scotopic system is more sensitive to shorter (blues and greens). At dusk, therefore, reds and yellows appear darker than they were, and blues and greens lighter.

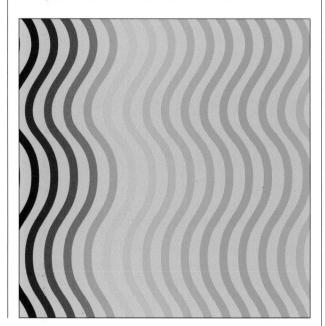

92

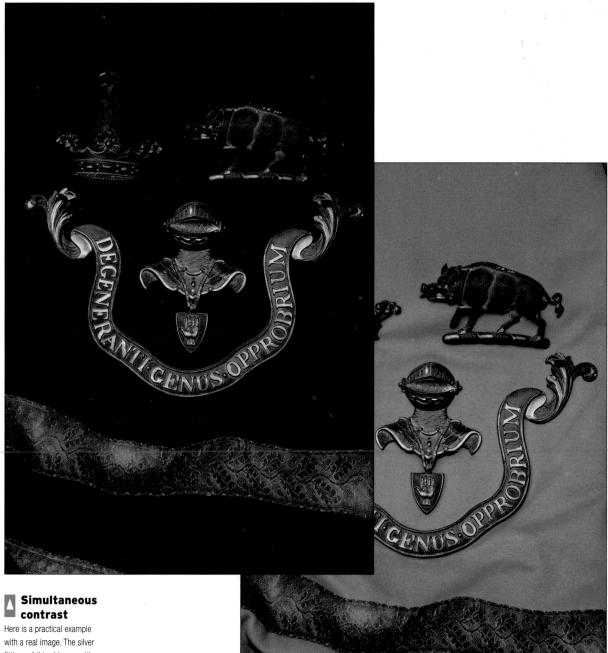

with a real image. The silver fittings of this old cape with a coat of arms acquire a different cast according to the colour of the cloth (the original was red).

Vanishing boundaries

This is the opposite effect from vibration, in which equal brightness between different colours can make the edge between them seem to disappear, or at least be hard to distinguish. This is sometimes visible with cumulus clouds that vary from white to dark grey against a blue sky – there is a mid-point at which sky and cloud seem to merge.

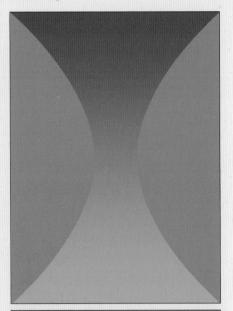

Vibration

Vibration is one of a family of flicker effects that had their moment of glory in the 1960s with the popularity of Op Art, notably by artists Bridget Riley and Vasarely. Arrangements of lines, dots, and patterns can be made to produce various kinds of motion and, at the same time, odd colour shifts, most of which are uncomfortable to look at for long. As the art historian Ernst Gombrich wrote: 'I admire the ingenuity and enjoy the fun of these demonstrations, and I realise that the artists cannot be blamed if we find them somewhat marginal in importance'.

Vibration occurs along the edge between two intense colours that contrast in hue but are similar in brightness. Red is the easiest colour to work with because of its richness and its medium brightness and, as the illustration here shows, the effect is powerful. The edge seems to be optically unstable; if you stare at it for long enough you can see a light and dark fringe. This optical vibration makes such pure combinations unsettling to look at for long, even irritating. The key is that the two neighbouring hues have the same luminosity and a sharply defined edge, and if you want to enhance vibration, the Hue/Saturation sliders provide the tools.

Interrupted colour

This effect has some similarities with simultaneous contrast, but derives its power from the presence of intense colours that interrupt the smooth perception of a single bar of colour. Although the eye remains convinced that the two pale bluish squares in the top image are different, removing the strong blue and yellow bands, as in the bottom image, proves that they are exactly the same.

A practical

application of optical effects is the choice of background, where the tendency of the eye to compensate for a distinct colour alters the perception of the object, in this case a cooked lobster. In four extreme examples (extremes of brightness and of colour contrast with the lobster), the colour appears to differ, particularly between the green background (a redder lobster) and the lobstercoloured background (less red).

Harmony

There is a strong argument for arrangements of colour that are likable, and it can be justified in terms of the colour circle and the placement of colours around it.

Complementaries across the circle

Using the colour circle from page 13, harmonious colour relationships can be worked out very easily. The only requirement is that the colours used are arranged symmetrically around the circle's centre. Given this, pairs and groups of three, four, and more produce a sense of balance.

The idea that certain combinations of colour are harmonious - that is, inherently satisfying to look at - is a persistent one. Painters, designers, and colourists in general have usually approached this from a gut instinct, but there is some theory behind it. Art historian John Gage identifies four classes of harmony theory: the analogy with music (harmonic scale), complementary

harmony (opposites on the colour circle), similarity of brightness/value, and experimental psychology (based on the reactions of test subjects). In addition, there is similarity of hue (a group of colours in one image from the same sector of the colour circle). Ultimately, harmony is a conservative view of colour that conforms to expectation. It is safe and comfortable, which is fine if you want images to be beautiful, but its opposite, discord, also has a role to play in art and photography. Generally these theories work, but the implication that images ought to be harmonious is a little dangerous. Nevertheless, we'll look at the combinations that most people find pleasing.

One clue to the way in which harmony can work lies in successive contrast: the after-image. By supplying an opposite colour, the eye is, in effect, restoring a balance. This is one of the main principles of virtually all colour theories: that the eve and brain find colour satisfaction and balance only in neutrality. We should qualify this by saying that an actual grey does not have to be present, only colours that would give grey if combined. One argument is that the eye and brain appear to mix the colours received. This is where the colour circle really comes into its own. Any two colours directly opposite each other on the circle give a neutral result when mixed. Such pairs of colours are called complementary, and their combination is balanced in a way that can be tested, as we saw just now with successive contrast. It was Goethe who observed that the eye compensates for one strong colour by creating its complementary as an after-image. We can take this further. Any combination that is symmetrical around the middle of the circle has a potential blend that is neutral and, therefore, balanced. So, three evenly spaced colours like the primaries yellow, red, and blue make a harmonious group, as do yellow-orange, red-violet, and blue-green. Sets of four colours can also be harmonious, as can intermediate and unsaturated hues.

Complementary pro-adjusted for brightness **Complementary proportions**

individual blocks.

Using the relative brightness of pure colours explained in the text, the balanced combination of complementaries, and of the basic three-colour sets, looks like these

Brightness and proportion

Brightness and proportion Even without considering complementaries, a combination of dark and light, tends to look more harmonious when the framing takes this into account. As always, however, harmony is not a rule, and is only one possible component in an image.

Chevreul, who discovered simultaneous and successive contrast (pages 93 and 95), took his results further than just proclaiming a law of perception. He made an aesthetic judgment: 'In the Harmony of Contrast the complementary assortment is superior to every other'. This assumption has been repeated many times since, and the optical effects that he found give it some justification.

Brightness comes into the equation. It is not quite enough to say that certain pairs and combinations of colours are harmonious. Each colour has an intrinsic brightness, so complete balance requires that the combinations be seen in certain proportions. In photography, this is complicated by the details of texture, shape, and so on. The colour in photographs is enmeshed in the structure of the subject. As a start, however, we can look at the basic combinations of primaries and secondaries introduced in chapter one. The complementary for each primary colour is a secondary: red/green, orange/blue, yellow/violet. However, we have already seen something of the differences in brightness among these six colours, and the strength of each in combination follows this. In descending order, the generally accepted light values, originally determined by the German poet and playwright J.W. von

Harmony by similarity Choosing a range of colours that are all adjacent on an arc of the colour circle ensures a comfortable relationship between them. The colour bar shows this diagrammatically and the two photographs show a practical application. An alternative is to modulate one colour by saturation.

99

Goethe, are yellow 9, orange 8, red and green 6, blue 4, and violet 3. When they are combined, these relative values must be reversed, so that violet, for example, occupies a large enough area to make up for its lack of strength. The areas needed for these colours are, therefore: violet 9, blue 8, red and green 6, orange 4, and yellow 3.

The colour blocks above (page 97) illustrate the ideal balance proportions of the three complementary pairs and the two sets of three. Other combinations can be worked out in the same way. For simplicity and continuity, the proportions shown here are for pure standard hues, but the principle applies to any colour, whether intermediate on the colour circle, a mixture, or poorly saturated. The brightness or darkness of the hue also affects the proportion.

There is a very important caveat to this principle of colour harmony. You can apply it with complete success, but its

foundation is the psychology and physiology of perception and no more. Used precisely it has something of a mechanical, predictable effect, and what you gain in producing a satisfying sense of equilibrium you are likely to lose in character, interest, and innovation. Colour harmony can show you how to make an image look calm and correct, but it is hardly conceivable that anyone would want all or most pictures to generate this impression. You should know the base-line of colour harmony, but only as a foundation. Good use of colour involves using dissonance and conflict where appropriate.

A different approach to harmony is unity through similarity, which essentially means choosing a set of neighbouring colours. These could be neighbours in hue - all from one side of the colour circle - or else modulations in saturation or brightness of a tighter set of hues. There is a long history in art of achieving a gentle, pleasing range of colours in this way. Art historian Kenneth Clark made the analogy that colours 'close together have a spectacular beauty - they are often like the faintly shadowed vowel sounds so often a source of magic in verse'.

Mixing with blur

One highly characteristic feature of photography is optical blur - a gradual softening and mixing of the image away from the distance at which the lens is focused. Gradated focus is even considered to make an image 'photographic', and received attention from Photo-Realist painters beginning in the 1960s. In terms of colour, defocusing blends hues, as these images show, this apparently natural optical effect has itself a harmonizing property, whatever the colours.

Red and green

This combination of the strongest hue (red) and the most common in nature (green) is frequent and powerful, although the most balanced mixture uses a bluish green.

Dacaranda On the margins of red, in the direction of mauve and purple, this lone flowering jacaranda tree in the Amazon rainforest nevertheless creates an image that draws on the red-green principle of harmony.

Pure red and pure green have the same luminosity, and so combine harmoniously in equal proportions. This, however, presupposes that both colours are pure and exact, though of course this rarely happens, and in practice there is little point in measuring the areas precisely. Indeed, although both red and green have the wide ranges we saw in Optical colour effects (pages 90-95), the actual perceptual complementary to red is closer to cyan than to green. In nature, red/green combinations are mainly limited to plant-life; although green is abundant in many landscapes, red is much less so. An early National Geographic cliché was a redjacketed figure in a landscape, as a simple means of drawing attention, and many photographers will seek to include an area of red in an otherwise largely green image, simply to draw the eye.

Red and green, when they do have the same luminosity and are saturated, exhibit the colour effect known as vibration, introduced on page 96. Irritating

Restaurant sign

The glass wall entrance to a Thai restaurant designed by a Japanese in Tokyo features a subtle pairing of the two colours for a delicate, intricate effect.

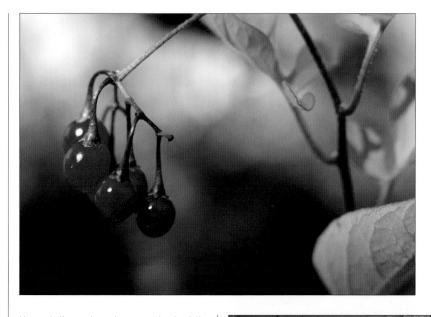

though it can be when you look at it for a period of time (and problematic for some types of TV screen and computer display for that matter), the effect is eyecatching and dynamic, and greatly enhances the energy of an image. To some extent it occurs between any two brilliant colours, but nowhere is the effect as strong as it is when red is involved, and it happens most distinctly between red and green.

As you might expect, changing

the proportions weakens the harmony. However, when the balance is extreme, the smaller colour acquires extra energy. As you can see in the photograph on page 88 (the aerial photograph of the farm buildings surrounded by fields) the strong red roof, far from being overwhelmed by the green of the fields, draws attention to itself insistently. Instead of a colour combination, we have a colour accent. The effect is stronger when red is on a green background than vice versa, because of the tendency of warm colours to advance while cool colours recede.

Berries

A sprig of glossy red berries in dappled woodland in New Brunswick appears all the more intense for being surrounded by green.

Mandala

A mandala made by pouring lines of rice onto a painted surface, at a Jain temple in Gujarat, India. The detail was cropped in-camera so as to give equal weight to the red and green.

Orange and blue

Of the three classic colour harmonies, orange/blue is probably the easiest to find photographically, because both colours are close to the colour temperature scale of light. Orange is twice as luminous as blue, so that the best balance is when the blue is twice the area in a picture. Compared with red/green combinations, this makes for less optical confusion about which colour is the background. It also drastically reduces the vibration, so that orange and blue are generally more comfortable to look at. The German expressionist painter August Macke described blue and orange as making 'a thoroughly festive chord'.

Metal

A modern house in

a range of primary

shutter

Ahmedabad, India, uses

colours in its decoration,

including these hand-

made metal shutters.

Haveli

An old courtyard house, or *haveli*, in the Rajasthani city of Bikaner, freshly painted in a pastel variation on orange and blue. The individual hues on the three images here are all different, but the combinations work visually in the same way.

Buddha and flame

Buddha and flame Using selective focus to combine this classic pair of colours, a blue-clad Buddha image in Koyasan, Japan, was photographed through the flame from a candle burning in front.

Orange and blue lie very close to the opposite ends of the colour temperature scale, so that they can be found in many common lighting conditions. A low sun, candle-light, and low-wattage tungsten light bulbs are some of the sources of orange - not pure, but close enough. On the other hand, a clear sky, and the light from it, is a ubiguitous blue. At sunrise and sunset, therefore, there is a natural complementary effect from the orange sunlight on the one side and the blue shadows on the other (and it was Leonardo da Vinci who appears to have been the first to notice this). As well as contrasting in brightness, orange and blue have the strongest apparent cool/warm contrast of any primary or secondary pair of complementary colours. This produces an advancing/receding impression and, with the appropriate setting, a relatively small orange subject stands out powerfully against a blue background, with a strong three-dimensional effect.

Reverse proportions

An interesting exercise, and one that's easy to perform digitally, is to reverse the proportions between the two colours. As shown here, make a duplicate layer and on this shift all the hues 180° using the Hue/Saturation control on Master. Then erase those areas from the upper layer that you do not want to alter - in this case, the faces of the girls.

If you change the image so that the orange now dominates a small blue area, the classic effects are by no means completely lost. As the result shows, the combination of the two hues alone is enough to produce a general sense of harmony. And, as you can see from the examples of colour accent on page 110, the eye is drawn to the smaller area of colour. In focusing just on this part of the image, the eye receives a local impression that is more balanced, with the blue seeming more powerful than its area merits.

Ship painting

A Greek fishing boat being painted on a quay. The expanse of blue hull, greater than seen here. and a clear space made it easy to choose a telephoto zoom setting to refine the proportions of the two colours.

At a restaurant in Mumbai, marigolds (the most widely used of Indian flowers) float in a blue pond. Again, camera position and cropping ensure that the orange area is proportionately smaller than the blue.

Yellow and violet

The third combination contrasts the brightest and darkest colours in the spectrum, with intense results, but the rarity of violet makes it an uncommon relationship. **This third complementary pair** combines the brightest and darkest of all the pure hues. As a result, the contrast is extreme and the balanced proportions need to be in the order of 1:3, with the yellow occupying only about a quarter of the image. At these proportions, the yellow is almost a spot of colour, and the sense of a relationship between the two is correspondingly weak.

Racquets

A presentation set of Real Tennis (an indoor game from which both tennis and squash derive) racquets to a member of the British royal family. Closing in to a detail made more of the colour relationship. The relative scarcity of violet in subjects, and settings available for photography, makes yellow/violet an uncommon combination, particularly as in the ideal proportions the violet must occupy a large area. One of the few reliable natural combinations is in flowers; the close-up of the centre of a violet is a classic example.

Parades during the Tuscan city of Siena's annual Palio horse races. The camera position was chosen to include all the components, and it also gives the opportunity to play with the yellow and purple colour combination over the grey buildings.

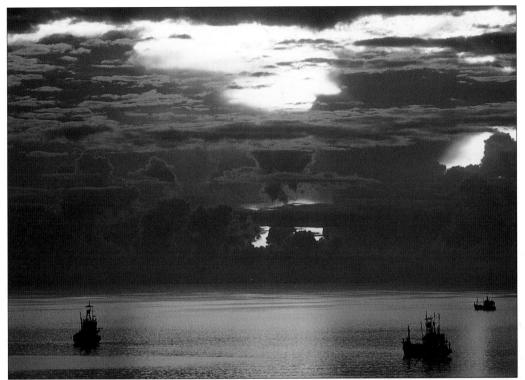

Stormy sunrise

Yellow-violet colour harmony is the principal reason for the attractiveness of this dawn view of fishing boats in the Gulf of Siam. Even though the two hues are pale, the harmony is persistent, and contributes to the calm, placid feeling. The contrast of hue has been deliberately enhanced, as shown on page 150, Selective enhancement.

The very centre of a violet contains this colour harmony. By closing in with a macro lens, the proportions can be adjusted.

Multicolour combinations

Relationships between three and more colours in one frame become complex, and depend on strength of hue to remain significant. The more colours that appear in a scene, the less likely they are to remain distinct as colour masses. At a certain point they merge perceptually into a colourful mosaic and lose their individual identity. Several small areas of the same colour do not necessarily add up perceptually to one single mass,

and in real life there are limited occasions for finding even a three-colour scene that is distinctive. Naturally, selective digital enhancement can help improve the relationship.

Three colour-coordinated Peruvian children crossing the square in Cuzco.

While red-yellow-blue is the most powerful mixture of pure hues, other less well-balanced combinations of colour can have similarly impressive effects. As you can see from the pictures on these and the following two

Painted Prahu

Although they are set among other, mainly neutral, hues, and scattered over the image, the intensity of the three pure primaries punches through to dominate this image of painted Balinese fishing boats. No other colour combination has quite the same power and intensity, even in small quantities.

Pastel harmony

Even though the colours in this house-painting scene in northern Sudan are not precisely equilateral, they are close enough for a harmonic relationship because they are essentially pastels – paler versions of the basic hues.

A market in the Comoros, with a brief coming together of four (see page 19) primaries.

pages, there is a major difference between groupings of strong, bold colours and those of delicate, pastel shades. Pure hues fight intensely for attention, and the strongest combinations are those of three colours. Even a fourth introduces excess competition, so that instead of building each other up, the colours dissipate the contrast effects.

Wherever you can find groups of pure colours, they make easy, attention-grabbing shots. Being unbalanced in their positions around the colour circle, they do not mix to grey in the visual cortex, and so contain the element of tension missing from the primary and secondary mixes on pages 96. Considered as part of an overall program of shooting, strong colour combinations are the short-term, straight-between-the-eyes images.

They fit well into a selection of less intense pictures as strong punctuations, but several together quickly become a surfeit.

We can extend the balancing principle of complementary pairs to three and more colours. Going back to the colour circle, three equally spaced colours mix to give a neutral colour (white, grey or black depending on whether light or pigments are missed). The most intense triad of colours is, as you might expect, primary red, yellow, and blue. The colour effect in a photograph depends very much on how saturated they are and on their proportions: equal areas give the most balanced result.

Enhancing triple harmony

Increasing the saturation appropriately will make colour relationships more distinct - though at the expense of subtlety and other image qualities. As an exercise, this image of a Shaker schoolhouse, already quite rich and sharply lit, has been given even greater saturation in Photoshop. The building itself, already neutral, is hardly affected, but the surroundings resolve themselves into a grouping of primaries.

Three-way balance

Evenly spaced around the colour circle, the three primary hues form an equilateral triangle. Together they cancel each other out, mixing to produce neutral grey. Also evenly spaced around the circle, the secondary hues balance each other in exactly the same way as the primaries.

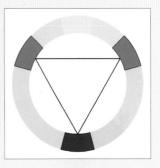

Colour accent

A small area of bright colour set somewhere in the frame and contrasting with the background is a special case in colour relationships with a particular relevance for photography. If we accept the idea of harmony as having some basis in the physiology of perception, with a tendency for the eye to seek some sort of balance, then it's easy to see how composition in photography naturally drifts toward certain proportions between masses of colour in a scene. The harmonious proportions that we looked at on the previous pages represent a higher comfort level than most. It does not,

of course, make them in any sense better. This idea of a natural set of proportions has a particular relevance in photography because so much of what we shoot is 'found'. Faced with a scene that appears to have the potential for a successful image, the usual tactics for composition involve closing in or pulling back, altering the zoom and moving the frame, and the proportions of colour brightness influence this to a greater or lesser degree.

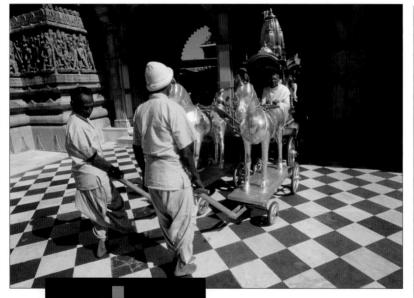

Silver chariot

One of the daily events in a Jain temple in India is the use of silver chariots and, while this is the real subject of the photograph, the use of two colour accents enlivens it. The separation of the yellow and blue greatly reduces the significance of proportions.

Yet when there is an extreme difference in proportion between colours - meaning when one at least is very small relative to the frame - the dynamics become those of a point within a field, the equivalent of a black dot on a white background. The proportions become, in effect, irrelevant. One colour becomes an accent, or spot colour, and the eye is very much pulled and directed by its placement. When the accent colour 'advances' from a 'retreating' background, the effect is at its strongest - as in yellow/red out of blue/green. Paradoxically, perhaps, under certain conditions the very localization of a small colour accent gives it more perceptual strength.

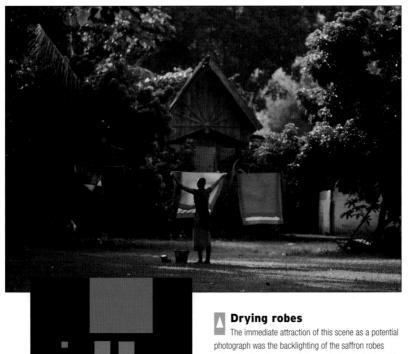

photograph was t enhancing the sill a wide shot was a bright orange colo

The immediate attraction of this scene as a potential photograph was the backlighting of the saffron robes enhancing the silhouette of the monk. The decision to take a wide shot was a desire to give context and to accent the bright orange colour.

Because of the small areas involved, it is possible to have spot colour combinations in which there are two or more different accents. This complicates matters because the two spot colours have a relationship between themselves as well as with the background. The most distinct effect is when the setting or background is relatively colourless and the two purer hues occupy localized areas. This effect was used by painters such as Delacroix and Ingres to promote harmony through variety in some of their paintings. They used scatterings of complementary colours such as blue and orange, and red and green.

This special form of colour contrast inevitably gives greater prominence to what painters call 'local colour', the supposedly true colour of an object seen in neutral lighting, without the influence of colour cast. Colour accents, above all, stress object colour.

Splash of red

Here, in a deliberately abstracted framing of downtown San Francisco, the splash of red reflection in the truck's panel helps to tie the otherwise neutral and metallic elements together into a coherent design.

Hip joints

Here the red accent, on one of a number of artificial hip joints, stands out from an entirely neutral background.

Discord

The negative of harmony is discord, equally subjective, dependent on opinion and liable to change. It has its own terminology, with terms such as clashing, strident, and vulgar.

Carnival

Carnival in Kingston, Jamaica is an occasion for an excess of energy, not only through music and dance, but visually. The whole idea is to be bright, not restrained.

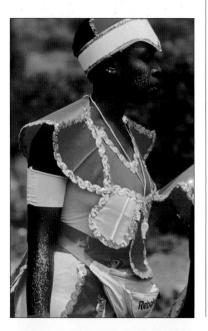

Just as the concept of harmony (page 96) is loaded with personal and cultural values, so its counterpart, discord, assumes a raft of opinions and prejudices. Moreover, the major underlying assumption is that there are combinations of colours that must somehow offend. This is not at all safe and yet, as with harmony, there is some truth in this, partly perceptual, partly cultural, partly to do with fashion. By definition, colours that clash cannot be from the same region of a colour model. They must be distinctly different, yet without the optical connection of being complementary. This means that at least one of the colours needs to be strongly saturated. Also, any optical effect that is uncomfortable to look at can enhance discord.

Beyond these fairly basic optical and perceptual principles, discord depends on cultural values, and also fashion. Culturally, the element of disapproval is strong, as you might expect, because colours that are thought to clash are in some way at odds with whatever is safe, undemanding, and conservative. Whether in choice of clothes or in interior decor, it raises the issue of good taste versus bad, where there are no absolutes. Possibly the most common use of clashing colours is in

advertising, as attracting attention overrides any questions of taste.

In art, discord is typically used to challenge assumptions, awaken the audience's attention and make statements. Kandinsky made this point forcefully in his *On The Spiritual In Art* in 1911-12 when he wrote that: 'harmonisation on the basis of simple colours is precisely the least suitable for our time...'

Japanese kitsch

A dispenser selling cuddly toys in a Japanese city street. Pink is one of the favoured colours of a deliberate kitsch, its garishness enhanced by the green glow of fluorescent striplights.

going on to proclaim that: 'Clashing discord ... 'principles' overthrown ... stress and longing ... opposites and contradictions ... this is our harmony'. Earlier, in *The Night Café* (1888) Van Gogh used discord to communicate what he wrote of as a place where one could go mad:

'I have tried to express the terrible passions of humanity by means of red and green ... Everywhere there is a clash and contrast of the most disparate reds and greens'. This may sound at odds with red-green

harmony, but he chose greens that tend towards a livid yellow.

Deliberately offending is also a staple of conceptual art, and it has the same possibilities in photography. To date, however, there have been few photographers who have made any notable use of clashing colours, and the reasons are not hard to find. Before digital, choosing colours in photography meant finding them in real life and composing to fit. As discordant colours tend to be avoided when most people are making colour choice, they are not common. British photographer Martin Parr is one of the few who have made a signature of this kind of colour combination because it is an integral part of his preferred subject matter - the vulgarity of the British on holiday.

Digital imaging allows such choice of colour to be made by the photographer independently of the subject matter, if wanted. Individual colours can be enhanced, shifted, or, if necessary, completely replaced. This is still an under-explored area. Like everything else in colour choice and manipulation, there needs to be a sound reason, and more conspicuously so if the aim is to increase visual discomfort.

Notionally the opposite of harmony, discord is, if anything, more problematic because of its negative connotations. To say that two or more colours in combination are discordant - that they 'clash' - is to suggest that there is something wrong about the choice. Just as there is an underlying assumption that harmony is generally a good thing, the idea of discord carries with it the sense that it is better avoided. These are clearly dangerous assumptions, if only because they rest on the idea of an established order.

Teej festival

In this annual celebration near Kathmandu, a line of Nepalese women exhibit a vibrant clash of brightly coloured saris. Discordant, certainly, but also full of energy.

Van Gogh's palette

It's always useful to learn from a master. In the first of these proportionate colour bars, taken from Van Gogh's *Night Café*, the painter strived deliberately for discord. Compare this with the colours used in *Bedroom At Arles*, in which he aimed for harmony.

Colour and sensation

Colour contrast resulting in a kind of harmony can also occur between groups of colours that evoke another sensory experience, such as heat or dryness. There are natural associations between physical sensation and colour. The strongest, and most natural-seeming, of these is between temperature and colour, but wet/dry contrast and day/night contrasts are also powerful. Flame and things glowing with heat are either orange, or close to it on either side on the colour circle (that is, yellow-orange, or toward red). The hottest colour as perceived by most people is, in fact, orange-red.

The colour of damp

A ruined gallery at a 13th century temple in Angkor Wat. The range of colours on a cloudy day, from green to blue-green, evoke damp, creeping moss, and dripping stones, in a humid atmosphere.

The sensory colour poles

Three different sensations depend on dividing the colour circle along different axes. The light-dark split of the colour circle is centred on yellow and violet respectively, the cool-warm division between bluegreen and orange-red, while wet-dry are cyan and orange-red.

Its complementary, opposite on the colour circle, is blue-green, and this gives the coldest effect (these temperature associations are real; a room decorated in shades of bluegreen does feel physically colder than one in orange-red, even if both are identical in temperature). The contrast between sunlight and blue sky, which is also the contrast between sunlight and shadow, occurs

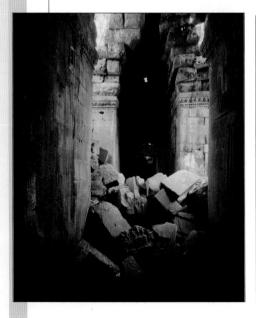

everywhere, and when the sun is low is exaggerated. At dusk, the colours in the direction of the setting sun are warm; in the opposite direction they are cool. Twilight gives a particularly cool background. Artificial lighting produces even stronger opposites. Tungsten lighting is yellow-orange on daylight-balanced film, and the lower the wattage and the dimmer the lamp, the more orange it appears. Fluorescent lighting appears greenish to blue-green.

Most of these are colour temperature effects, and it is important to understand the differences between this scale and the cool/warm contrast of the colour circle. They are similar, but not identical. For instance, the colour temperature scale goes from hot (orange) through white hot to extremely hot (blue). This is physically accurate, but outside our normal experience. On the contrary, we associate blue with cool things, not with extreme heat. The second difference, a small one, is that the range of colour temperature is not along a scale of pure colour; both the orange and blue at either end are a little dull in comparison with those of the colour circle.

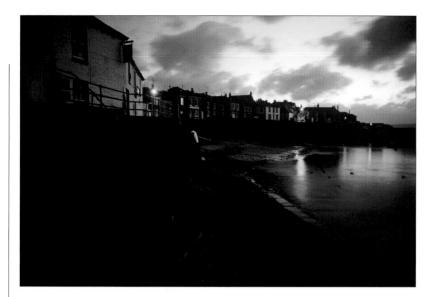

Cornish dawn

With nearly an hour to go before sunrise, the light from the eastern horizon over the fishing village of Mousehole in Cornwall, England is suffused with a range of blues, giving a distinct impression of a cold start to the day.

Shaker box

As the sun sinks towards the horizon, the light becomes more orange. Its rays pass through more atmosphere and this filters out the cooler colours – the shorter wavelengths – by scattering.

Colour is also linked to humidity, with 'hotter' colours and those associated with aridity, sand, and dust evoking dryness, while greens and blues naturally suggest water and wet vegetation. Thirdly, brighter colours can be thought of as colours of daylight, as opposed to the darker ones related to evening and night. The validity of these opposed sensations relies on dividing the colour circle in half (see box, left).

Cool colours

Underwater views always appear cool because of the selective absorption of light. Although the sunlight striking the surface of the sea is virtually white – mixture of all the colours of the spectrum – water absorbs the spectrum progressively. That is, as the depth increases, more of the spectrum is lost, from the red end toward blue. At about 20 feet (6m) in clear water, all red and orange has been absorbed, leaving only the cool colours.

Warm colours

Close to sunset, the sunlight becomes more orange. The closer the sun is to the horizon, the more atmosphere its rays pass through, and this filters out the cooler colours – the shorter wavelengths – by scattering. This is progressive, like the absorption of warm colours by water; as the sun sets, the colour moves from white to yellow, and then toward orange and red. Atmospheric conditions determine the exact colour.

These are polar opposites in groups rather than in single hues. The contrasts can effect other associations, such as the suggestion of distance. Because cool colours recede and warm colours advance, blue-green and its neighbouring colours are associated with backgrounds and distance. If the colour of a subject is warm, and that of its background cool, the impression of depth is heightened. This is a different depth sensation from the one created by light/dark contrast, but if the two are combined (a pure orange against a deep blue, for example), the impression is slightly stronger. As a result, a small area of a warm colour set in a larger cool-coloured frame always looks appropriate. Another association, also related to our experience, is that pale cool colours suggest transparency and airiness. This comes in part from the blue colour of a clear sky, in part from the pale blue of things seen at a distance through atmospheric haze.

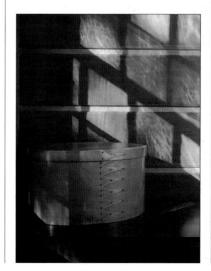

Muted colours

The majority of colours facing the camera in the real world are very far from pure, and while the impact is less, the subtle variations can be very enjoyable. In traditional colour theory, the pure colours have prominence, and painters are trained to construct hues from the primaries and secondaries. In contrast, photography deals almost exclusively with the range of colours found in the real world, and its colour priorities are consequently different. As we have seen through cataloguing the principal hues, they are not particularly common in nature. Most found colours can

be seen as 'broken'; that is, they are seen as a mixture of hues that gives a deadened, unsaturated effect.

Such muted colours are, however, very rewarding to work with, because of the great variety of subtle effects. Colour theory gives an artificial stress to the pure primary and secondary colours, as these are the foundations of all other; it would be a mistake to infer that pure hues are inherently more desirable in a picture. The differences between soft colours are on a much narrower range than the pure colours, and working constantly with them trains the eye to be more delicate in its discrimination, and to prize rare colours. Russet, sienna, olive green, slate blue - these and an almost limitless variety of others, including the chromatic greys, make up the broad but muted palette of colours available for most photography.

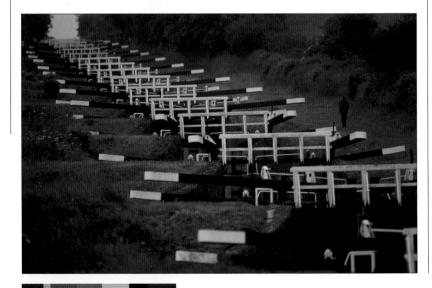

Muted colours
PAPAYA WHIP
BLANCHED ALMOND
BISQUE
PEACH PUFF
NAVAJO WHITE
MOCCASIN
CORNSILK
IVORY
LEMON CHIFFON
SEASHELL
HONEY DEW
MINT CREAM
AZURE
ALICE BLUE
LAVENDER
LAVENDER BLUSH
MISTY ROSE

Caen Hill A remarkable flight of locks in the English canal system. The extremely diffuse light of a dull day is ideal for this image, allowing the geometric succession to dominate.

Pastels Faded jeans and a pale yellow Samba dress have a pastel effect during 'Brazilian day' on the streets of Paris.

though colourful, of shutters and a balcony in the Rajasthan city of Jaipur. As with the shot on page 107, this is an example of pastel colour.

Darkness, as in shadow detail, is necessarily devoid of strong colour, as the Dutch tenebrist painters such as Rembrandt and Frans Hals discovered. These 'painters of shadows' excelled at their handling of the lower tonal range by using palettes that were almost monochromatic. This takes us back to the chromatic neutrals that we saw on page 58.

At the other end of the brightness scale are pastel colours. These, from a painter's point of view, are created by adding white rather than grey or black, so that they are never muddy in appearance, but rather soft, delicate, pale, and light, retaining a hint of the purity of the original hue from which they derive, without the strength.

Soft furnishings

In a modern Indian apartment, beige and pale silvery greys are the designer's theme for this corner, with an organza screen, sofa and cushions.

Roast suckling pig

Brown, here in a rich, reddish form on the glazed skin of spit-roasted pork in a popular restaurant district in Manila, is the most well-defined of all muted colours. Others, such as drab greens, are variations of more saturated hues, but brown is always under-saturated.

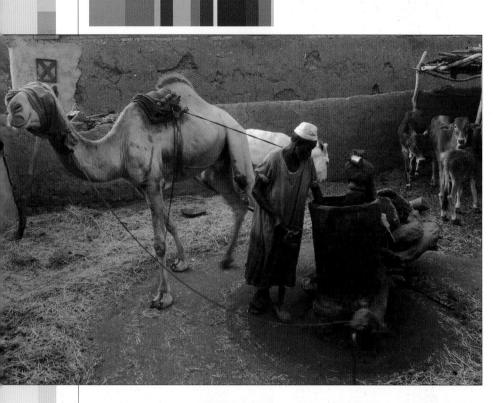

Sesame grinding

A blindfolded camel grinds sesame seeds into oil in a Sudanese town, in a scene that has not changed since biblical times. The muted colours contribute to this agelessness.

The subdued colours of fall leaves on a Scottish hillside recede even more under grey daylight and with a slight softening filter applied.

Lion kill The heat and

The heat and dryness of the African savannah come across strongly in this shot of a lioness exhausted in dragging the carcass of a wildebeest back to her cubs. Pale sandy brown is the colour theme.

119

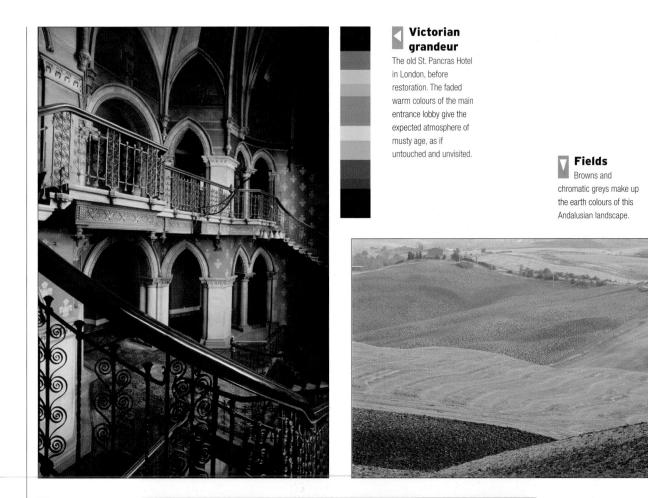

Hill town The browns and grey-browns of a Tuscan town perched high in the hills blend together in late afternoon sunlight. Of all colours, brown is the one usually evoked by Tuscany.

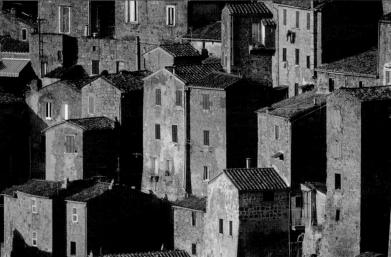

Case study: brown

If you are taking a set of pictures that are intended to be displayed together, there may well be an advantage in linking them graphically. There is hardly ever any point in trying to force this, but one opportunity that sometimes arises is colour. The subjects may have a particular range of hues, or, quite commonly, the setting may have certain colours characteristic of it.

Two Akha women wearing the traditional headdress that features silver balls sewn into the fabric.

Dust storm Girls returning from the water spring in single file protect their eyes from dust whipped up by the wind.

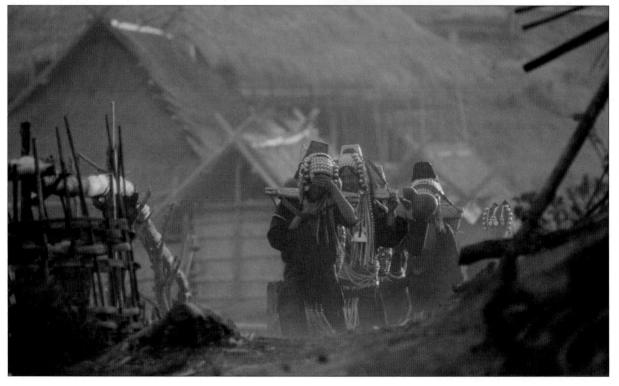

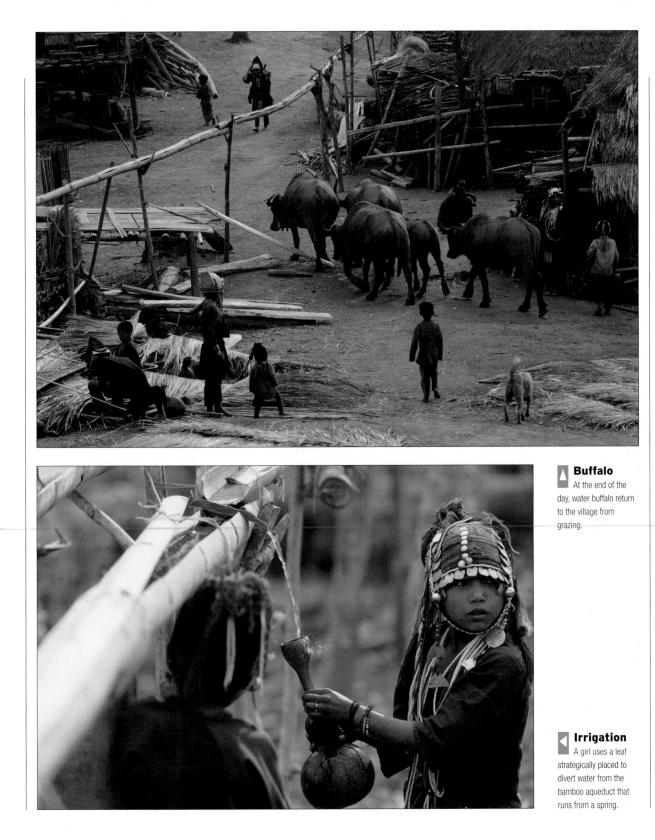

Case study: flesh tones

Flesh tones are rightly considered the memory colours par excellence, on the grounds that almost everyone can spot even a slightly wrong colour shift. And vet there is a seeming paradox in that the full range of human flesh tones is enormous. Not only that, but it divides into a few quite different core groups - a question of anthropology, really. The actual case is that we best know the flesh tones that we see every day. Dedicated memory-colour software such as iCorrect Professional tackles this huge variety by using a relatively broad special colour space, and by allowing the user to sample several colours at once.

To access the Editor, just click below the gradient symbol in the top left of the screen when Photoshop is open. By default, there will be two colour stops, one at each end of the gradient being displayed. Click the left-hand stop, immediately below the bar, then move the cursor over to the image of the face. It becomes a dropper. For consistency, click on a dark part of the skin. Then click once below the bar in the Gradient Editor to create a new colour stop. Move back to the image of the face and select a different skin tone. Four or five stops should be sufficient, and it helps to progress from dark to pale, left to right.

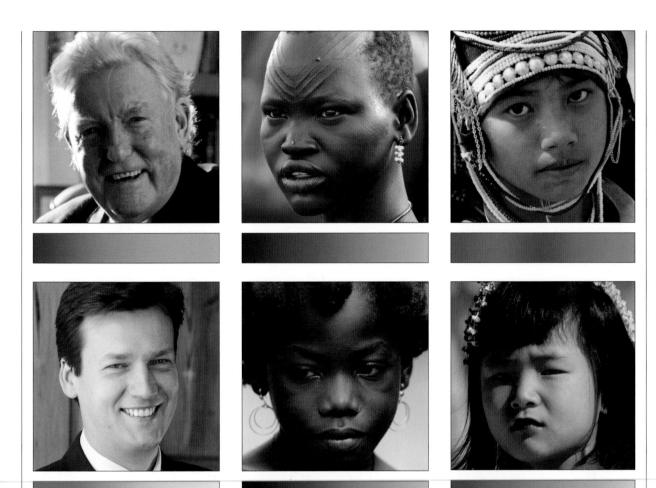

M Faces

Here we take a number of portraits, optimized as much as is practical to create the semblance of consistent, neutral lighting. We can now analyze the colours by sampling different parts of each face. When you have finished, you will have a gradient map of the skin tones for that face, arranged linearly. Give your new gradient a name and click New to save it into the gradient collection. If you now open a new blank image file, choose the gradient you have just created and use the gradient tool to apply it.

As you can see, even within any one face there are environmental reflections really come into play, particularly with a blue sky. Between ethnic groups, the range of skin tones varies even more, as illustrated by the combination of these seven into one 'colour space'. If accuracy of flesh tone is important to your photography, it might be worth constructing and adding to such a 'flesh' colour space yourself with every portrait that you shoot.

Iridescence and metallic colours

This special class of coloured surface has in common a colour and tonal shift that varies with very slight changes in the angle at which they are seen.

Iridescence is a spectral effect in which there seems to be a play of colours across the surface. and it changes with viewpoint and the angle of reflection. Diffraction, refraction, and interference effects play a part, and it appears in a wide range of materials and conditions, including oil slicks, soap bubbles, clouds, mother-of-pearl, stresses in plastic seen under polarized light, and more. There are even specific terms for particular substances, such as pearlescence and opalescence. Interference occurs when trains of light waves interact with each other, often from the upper and lower surfaces of a transparent layer. There is a transience and impermanence about this, either to do with time (in the case of iridescent clouds as shown here) or with angle of view. In either case, photography is uniquely well-equipped to capture it.

Thai silk cloth

The brocaded version catches metallic reflections, but the silk itself exhibits a shot effect, which has been exploited by the weaver in using different colours for the warp and weft. Gentle folding in both cases shows these effects to their best advantage.

Autos at night

The reflections of direct artificial lights over a parking lot are intense and concentrated in the polished metal of these automobiles. Note the slight colour shifts that accompany the variations in tone.

Metallic colours comprise another group that has its own unique characteristics. What distinguishes these colours is the special gradient of shading toward the highlights, and the extremely subtle shift of hue which accompanies it. In particular, metallic surfaces have a fairly high reflectivity and so pick up the tones and colours of their environment. As this is overlaid on the inherent

colour of the metal, the effects can be interesting and dynamic. Different metals have inherently different colours and degrees of reflection, which makes them recognizable as, for instance, gold, silver, lead, or aluminum. The type, quality, and direction of the light source make all the difference. If you have sufficient control to alter it, experiment with the variety of effects. In the case of the titanium jewellry shown here, interference and metallic effects combine.

In textiles, particularly silks, there is a technique of weaving in which the weft and warp, differently coloured, are alternately dominant depending on the angle of view. Shot fabrics, as they are known, have a play of colour that recalls iridescence. Capturing it in photographs relies on clearly modelled folds in the cloth.

Java The leaden finish of this Javanese statue appears metallic because of its particular reflective qualities. The textured surface and diffused light from an overcast sky produce a relatively even gradient of tone.

Gilded stupa

Mother of pearl

The all-seeing eyes of the Buddha look out in the four cardinal directions from the square gilded harmika of the stupa of Swayambhunath, Kathmandu, Nepal. An old Indian decorative technique, inlaying mother of pearl into stone. Mother of pearl is the nacreous inner coating of certain shells.

A pattern of artificial fibres showing bright interference colours when seen through crossed polarizers.

Police shields

Bored police in Manila await the start of a demonstration. Their scuffed shields are in low-tech aluminum, which has a dull tone in the soft afternoon light.

Bubbles A mass of soap

bubbles glistens with rainbow hues – an interference effect due to the extreme thinness of the surface.

Polarized plastic Plastic pushpins, a

Plastic pushpins, a plastic box, and a disposable hypodermic, all photographed with crossed polarizers to show stress polarization, an interference effect.

Case study: images in sequence

In addition to the colour relationships within an image, photographs are more often viewed in groups. Whether hung side by side as prints on a wall, facing each other in a magazine spread, or in sequence as a slide show, the colour relationships between the several images impose their own structure. Sequence is involved however they are displayed, because the eye travels from one to another. All the principles of colour interaction that we've looked at in this chapter apply, from successive contrast, to unity through similarity, to harmonious and discordant contrast.

Magazine spreads

Because the units of colour are entire images, the juxtaposition of photographs tends to favour those with a dominant colour, as the example here illustrates. In this case, a fine example of skilled art direction with an eye to exploiting colour, a 58-page story was constructed from several hundred photographs of India. The opening spreads of *Seven Seas*, an award-winning premium travel magazine from Japan, are shown here, reading from right to left. The images were selected and juxtaposed with colour very largely in mind. In particular, the art director has made colour work in the typography, and in the sequencing of the photographs.

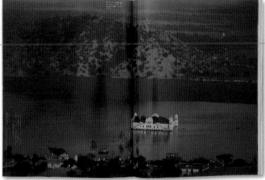

Choosing and Using

Using colour, in the sense of exercising precise control, has traditionally been a problem for photography. Put simply, the means were limited. Black-and-white film photography, with its much more restricted range tones without hues - offers plenty of scope for exactness and interpretation, and darkroom printing is the second phase of what can be turned into a long process, if the photographer wants. Colour film is less generous. Two generations of photographers learned a kind of photography that, to all intents and purposes, ended when the shutter was released. Kodachrome and its successors allowed very little messing around during processing, restricted to pulling and pushing for guite small changes in brightness, always with unpleasant side effects on colour cast, density, and graininess. The only way of printing from a colour slide to high quality and with control was the dye transfer process - highly complex and demanding, and in any case was

eventually abandoned by its supplier, Kodak. Colour negative film was more tractable, but still tricky to print well, and hardly intuitive.

Colour control, then, depended with film on just two kinds of technique. One made use of the characteristics of the materials for whatever reasons they existed, such as the subtly different dye response in film. The other was - is - the organization of the scene in the viewfinder, a huge area of choice. This is no less relevant in digital photography, and remains the core skill. It certainly dominates the discussions in this book. And yet the different technologies of photography always play their part, and with digital capture and digital image editing there is suddenly a spectacular expansion in control and discrimination. The issues are not just what to do with this, but how to achieve a sensible balance between the taking of images and manipulating them.

Colour as the subject

There is a clear difference between a photograph in which there happens to be colour, and one in which the colour works to make the image what it is. **This is a slightly dangerous area,** full of creative pitfalls. At least, it's easy to attract criticism by attempting to discriminate between colour and the physical subject. As we've seen, colour excites opinion, and the very imprecision of the means we have for talking about it means that there are many standards

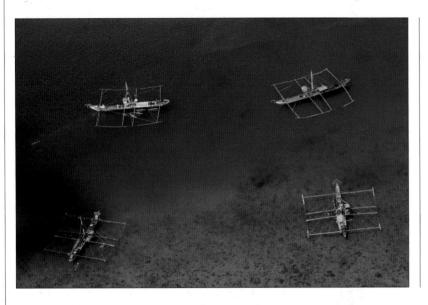

for judging it aesthetically. One area of dispute is to what extent colour per se can legitimately be the subject of a photograph. And it really is a matter of opinion.

John Szarkowski felt that one of the two 'categories of failure' of colour photography was concentrating on 'beautiful colours in pleasing relationships' (the other was simple inattention - taking blackand-white pictures in colour). I'm not at all sure that 'beautiful' and 'pleasing' are such bad qualities in a photograph, but they tend not to be

Fishing boats

While the subject matter in this aerial view of basligs, as these Filipino boats are known, is inherently interesting, it is colour that displays the depth and richness of the tropical sea. highly regarded in art criticism. The point being made is that to be seduced by a swatch of paint may not be enough to justify an image. The result can be, as an art director friend, Bob Morley, used to put it, 'a picture in search of a subject'. The terms may be a little vague, but the issue is real enough.

We can identify a scale of colour importance ranging from images which could as well be, and may be even better as, black-and-white, through those that benefit from their colour component, to some that exist because of colour and without which would be pointless. The obvious test, and easy to perform digitally, is to convert the image to monochrome, in Photoshop either by *Image > Mode > Grayscale*, or by *Image > Adjustments > Desaturate*.

But who should say? Obviously the photographer, although colour opinions tend, as usual, to be a free-for-all. Szarkowski's dismissive comment: 'Most colour photography, in short, has been either formless or pretty' refers

to his idea of two alternative failings. In the first, 'the problem of colour is solved by inattention' and the colour content is 'extraneous - a failure of form', a criticism only valid if the intention was to work with colour. Magnum photographer Ian Berry once remarked to me that he photographed in blackand-white even when he was using colour film (necessary for most magazine

assignments). As a reportage photographer, he wasn't interested in the colour. Not paying attention to colour is not a failure, rather an attitude. But if you are attuned to colour, the next precondition for a colour-orientated image is finding it, and, just as good moments of human interaction happen only occasionally in reportage photography, interesting colour combinations present themselves only from time to time - and whether they appeal or not depends on personal taste.

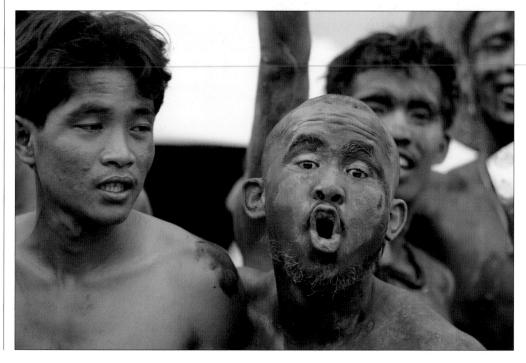

Aircraft

This image is less a document of a vintage aircraft than a display of a classic colour combination, simply rendered.

Drunken revellers

As part of the annual celebrations at the start of the hoped-for rains in northeast Thailand, during which homemade rockets are launched, participants paint themselves gaudily, and colour is very much the subject.

A colour style

In the context of colour, style means an identifiable palette and a way of handling it, but it carries the risk of being caught in a narrow niche. Style in colour, as in most areas of creativity, is widely considered a good thing to have – a sign of having achieved some kind of identifiable maturity. However the definition has usually been vague. The tightrope being walked is between style and mannerism, which is much easier to identify, and easy to fall into by

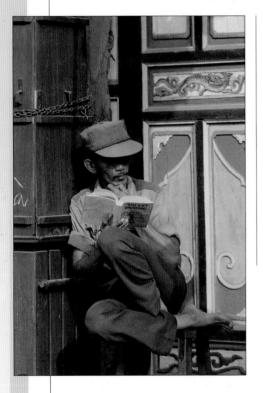

trying too hard to develop a style. The technique or trick takes over and you end up with a series of images that are distinct, but too deliberate. And viewers don't like having style pushed in their faces; it is similar to explaining a joke at the same time as telling it. Probably most photographers go through some stages of experiment with this or that technique, whether during picture-taking or processing, but getting stuck in something as noticeable as, say, colour-graduated skies, is generally a shallow idea. That said, the term style is often used vaguely, particularly in relation to individuals, whether painter or photographer. We are on safer ground when talking about collective works, schools, and movements. In that sense, style is definition.

Here, I'm restricting the definition even further and limiting it to the way in which photographers handle colour. It's important to try and distinguish between style and technique, as the latter, which is easier to identify, is

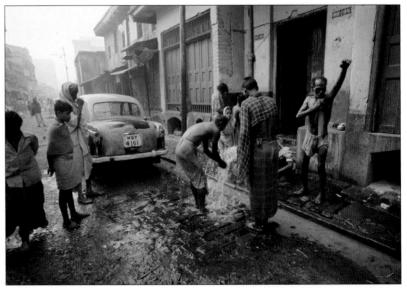

Colourful Again, where the situation makes it possible, the evident enjoyment of colourful scenes is a stylistic choice, as in this street scene of a man reading outside a temple in Vietnam.

Muted

Another street scene, but a different, sadder, colour handling, the saturation turned down, and with a gentle colour cast suffusing the image of inhabitants of one of the poorer districts of Calcutta.

135

commonly confused for style. I say 'try' because there are no clear lines of division, and technique (including, for example, using flash to eliminate shadows and so increase the area of bright colour) builds up to style.

Techniques for handling colour in photographs are straightforward to grasp and use, and many of them are described in this book. Some tend toward the procedural, as in a sequence of actions in Photoshop to select and shift certain colours. Others are observational – a way of choosing colour combinations by composing and framing. Whatever the techniques used, they tend to add up to a style through the exercise of choice and creative judgment, all with a purpose. Among painters, for example, we could look at the identifiable colours of Van Gogh, Matisse, Francis Bacon.

Among photographers there are a number of well-known colourists whose work is recognizable simply by their choice of, and management of, colour. Generally, they've either established an identifiable colour style or else concentrated so single-mindedly on it that it has become, in effect, theirs. Among the most obvious are Joel Meyerowitz, Jan Groover, Ernst Haas, Martin Parr, Alex Webb, and Eliot Porter, each very different from the other.

Finally, you might argue - and it has been, often - that any style is a limitation, and a talented photographer should be above this and be able to draw on a wide and varied set of skills according to the situation and the job at hand. Style is sometimes just in the eye of the person looking at photographs, rather than in the mind of the photographer taking them.

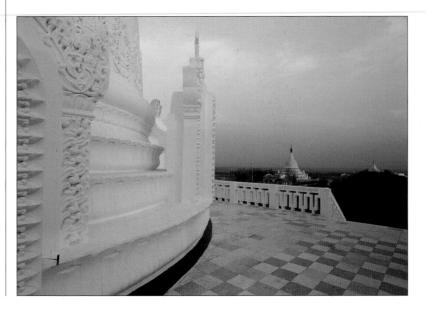

Evening

Dusk on Sagaing Hill, near Mandalay, Burma. The deliberate avoidance of an obvious subject forces attention onto the interplay of delicate colour, reflected in the whitewashed side of a stupa.

Minimalist colour

Being drawn to a single strong colour, and adjusting the framing and exposure to focus on it, is one kind of style. As in all reportage photography, it depends first on opportunity.

Rich and intense

In colour photography, the principal stylistic dispute remains between dramatic and restrained colour, with the former winning the popularity stakes but at the receiving end of art criticism. While there are many colour styles possible in photography, particularly now that digital imaging allows such thorough control and manipulation, the lines are drawn most firmly between rich and delicate palettes. Most colour styles can be placed quite legitimately in one or the other group.

The dispute erupted in the 1970s with the emergence of what became known as New Colour, principally in the United States. Although the new photographers,

Palm oil There were many ways of photographing these bottles of palm oil for sale in a Sudanese market, but this shot goes deliberately for maximum colour by closing in, shading the lens, and using the sun as backlighting.

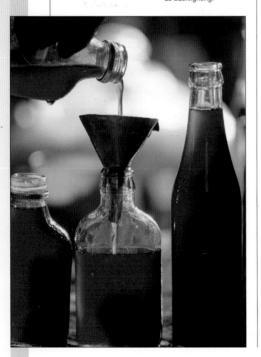

including William Eggleston and Stephen Shore, worked independently, they had certain identifiable characteristics in common, including a retreat from the obvious and dramatic, a celebration of the ordinary, and a largely deadpan approach to colour with a strong conceptual component.

In fact, what they especially had in common was that their work was not much like the kind of colour photography that has always been generally popular – with rich, saturated, strong colours – and it was this negative definition that made them largely favoured by museum curators. The photographer most strongly associated with saturated colours, and a firm, colourful choice of scene and subject, was Ernst Haas. Very popular in his heyday, Hass was an influence on Pete Turner, Jay Maisel, and Galen Rowell, as well as colour magazine photography, as in *National Geographic* and *GEO*.

The trait of saturated colours and good contrast was originally very much associated with Kodachrome. When slightly underexposed, its colours become richer, and this became a common professional technique. To its users, Kodachrome made colour photography exciting (and for many years *National Geographic* used nothing else), but to the art crit lobby it was anathema. Pete Turner could claim: 'I've been noted for my strong and rich colour saturation and I couldn't have achieved it without Kodak', but at the same time, Haas was referred to pejoratively by one critic as the 'Paganini of Kodachrome'. Szarkowski, who made no secret of his rejection of intense, sensational, popular colour photography, damned Haas with faint praise by writing: 'The colour in colour photography has often seemed an irrelevant decorative screen between the viewer and the fact of the picture. Ernst Haas has resolved this conflict by making the colour sensation itself the subject matter of his world. No photographer has worked more successfully to express the sheer physical joy of seeing'. The same argument, incidentally, was also used by William Egglestone, from the opposite camp to Haas, calling his subjects 'no more than a pretext for the making of colour photographs'.

Velvia film from Fuji eventually took the mantle of delivering saturated colours from Kodachrome, and it's interesting to look at the influence of film brands on colour style from the newer perspective of digital photography.

The effects that are either loved or despised are not only now measurable in saturation and per-channel contrast, but completely malleable. Rich colours, golden evening sunlight, rainbows, chiaroscuro, shafts of light piercing darkness, are all part of a positive, affirming way of seeing. They are, above all, popular - easy to enjoy and not especially demanding. Try taking a set of digital photographs on-screen in Photoshop, put aside any idea that they might have a 'correct' appearance, and choose the level of saturation or desaturation that you prefer. Most people opt for rather more than less saturation.

Dyeing feathers

An Akha hill-tribe woman (see also page 120) uses a natural dye on chicken feathers. Red is the most intense of colours and is always eye-catching, and here catches the viewer by surprise.

Royal elephant

While the elephant, belonging to the King of Thailand, is not inherently colourful, the treatment is, using a low sun from behind the camera and a low exposure to prevent the red pillars of the royal stable from washing out. Catchlights in the eye and in the water add to the impression of richness.

Restrained and commonplace

Desaturated palettes carry with them overtones of sophistication and subtlety, and a deliberate rejection of the popular, but handling them demands a sure touch to avoid being simply ordinary. On the other side of the art critical line is restrained colour. This is an argument that goes back much farther than photography, and 'a disdain for colour' as John Gage puts it, has in a number of cultures 'been seen as a mark of refinement and distinction'. And while the debate really got going in the 1970s, it had its beginnings with the availability of colour film. Before this, photographers became comfortable with black-and-

Colours in shade The muted light and old clothing of this boy worker in an Indian carpet workshop are both reductions of colour. Together with the muted colours of the carpet, they impart a kind of melancholy to the tightlycropped scene. white despite what might be thought of as its shortcomings, not least because its monochrome palette made a point of distinction from painting, with which early photography was often compared. The arrival of colour complicated the aesthetic of interpreting the visible world, or, in Szarkowski's words: 'For the photographer who demanded formal rigor from his pictures, colour was an enormous complication of a problem already cruelly difficult'.

Colour was harder to control, too. Colourists in the style of Ernst Haas had difficulty finding the scenes, viewpoints, and lighting that would deliver the

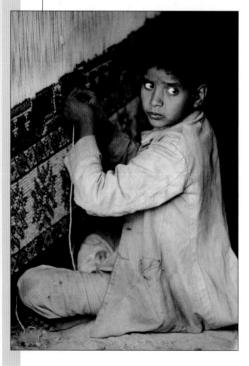

Dust and age have combined to fade the already subdued colours of an abandoned kitchen that was part of an old English country estate. Shooting toward the light further reduces the saturation. richness and spectacle they wanted, but those insisted on restraint and nuance had an equally demanding task. One solution was to shoot in controlled studio conditions, or at least indoors (Jan Groover, for example), where the lighting could be altered and things moved. An outdoor alternative was to shoot at times of day when the light would be less definite, such as dusk, or in overcast weather conditions. In colour terms, revealing nuance means paying extra attention to the context - surrounding tones and colours. Juxtaposition and composition are as important as in rich-colour photography, but need to be exercised differently and usually with more fine tuning, even more slowly. Digital photography has transferred some of this work to postproduction, and can give the photographer more freedom.

One technique for restraining colour is to work with a more limited palette, imposing a kind of unity on the image by choosing to shoot

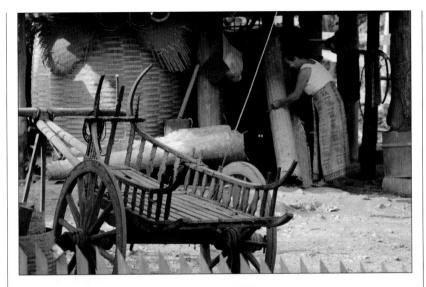

colours that are similar in one way or another (basically, either hue, saturation or brightness). To quote an example from one of the New Colour photographers, the American Joel Meyerowitz made a successful series of sparse landscapes around Cape Cod, paying particular attention to the unity imposed by light. On one occasion he was struck by the overall impact of blue on one scene, writing about: '...blueness itself. It was radiant. It had depth. It had everything I might possibly compress in my whole being about blue'. In fact, Meyerowitz, although often lumped in with Eggleston, Shore, and others for critical purposes, was more of a formal colourist.

Limited palette

Soft shaded light helps to blend the very restricted colours in the yard of a house in Mae Hong Son, Thailand. Cropping eliminates all but the greys, pale blues and variations on beige.

Mono look

In this almost silhouetted shot of a Burmese man in a Rangoon café, colour is almost completely absent. The image could as well be in black and white, although the hint of colour itself establishes the monochrome nature of the scene more strongly.

Colour and place

The colours associated with scenery, local weather, land use, and culture can in some locations be so characteristic that they help to give definition to the sense of place.

Korea

Purple and brown, particularly in combination, are associated with traditional temple and some domestic architecture in Korea. National and cultural preferences for certain colours can be identified almost everywhere.

A recurring theme in photography, particularly of the kind that involves travelling and reportage, is that of the essence of place - the idea that there are visual characteristics sufficiently distinctive to capture in a well-chosen set of photographs. Often this is ambitious, because in practice many of the most telling images in photography have a universality that transcends location. Nevertheless, travel photographers, and those who explore a defined territory, try by various means to define a sense of place, and colour is one of the qualities that they use.

The extent to which a place or culture can legitimately be said to have its own identifiable colour palette depends partly on the individual photographer, which is perfectly in accord with the personal subjectivity of colour. It also depends on how distinctive it is as a location, and how much it is set apart from elsewhere. The factors that contribute the most to this colour definition are the basic elements of the habitat - rock. soil, vegetation, and the way in which the land is used, all modulated by season, climate, and day-to-day weather. Occasionally, people refer to the special quality of light in one place, and this may indeed be partly due to some special condition of atmosphere - crystal clear in the high Himalayas, for example, or even a kind of beneficial pollution such as the haze of burning cow dung in parts of rural India in winter, or the smog that used to give Athens its famous sunsets before it was cleaned up.

📍 Tea plantation

The Nilgiri Hills in southern India are famous as the source of some of the country's finest tea, and the terraced plantations are completely distinctive. Green defines the place.

Bay of Fundy

A fishing trawler coming into harbour at dawn near Newfoundland. The soft blue connotes the cool wetness associated with this northeastern coast.

Athens Sunset across the Anafiotika slopes of the Parthenon – an old photograph that shows the pollution for which Athens was famous, and which typically gave atmospheric sunsets.

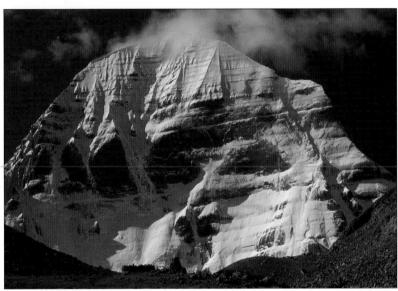

Tibet Mount Kailash on the high western plateau of Tibet. Piercingly sharp light and intense blue sky are characteristic of highaltitude countries like this.

Case study: New Mexico

Some places simply have more of an identifiable personality than others. New Mexico is one of these, in particular the area around Santa Fé and Taos Pueblo. It has a history of adobe building which gives it an architectural character, and has drawn artists and photographers who have in turn embellished and enhanced its colour palette. Adobe is rammed-earth construction, ideal for a land that has limited forests but easily accessible earth – and little rainfall. Style and colour are principally a fusion of the pueblos and the Spanish settlers.

Colour accent

A different shade of bluegreen colours a window frame set below a roof water spout in another pueblo – San Ildefonso. Here the adobe is from a warmer-toned earth. As in the other images here, an adjacent colour bar shows the key colours at a glance.

Pueblo style

One of the continent's most striking pieces of traditional architectural is the centuries-old multistoried complex of Taos Pueblo, all in adobe. This typical decorative treatment, an accent of near-turquoise against the earth base, is one of the foundations of New Mexican colour style. Cottonwood Cottonwood trees are characteristic of New Mexico's flora, and in fall add a range of hues from yellow-green to orange.

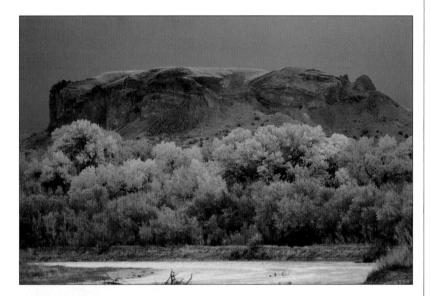

KiMo Theatre

Opened in 1927, the KiMo theatre (named after 'mountain lion' in one Pueblo dialect) in Albuquerque is a magnificent example of locally inspired Art Deco. These ceramics and other decorations are the work of Hollywood architect Carl Boller, who painstakingly researched the colours and motifs of both the pueblos and the Spanish mission styles.

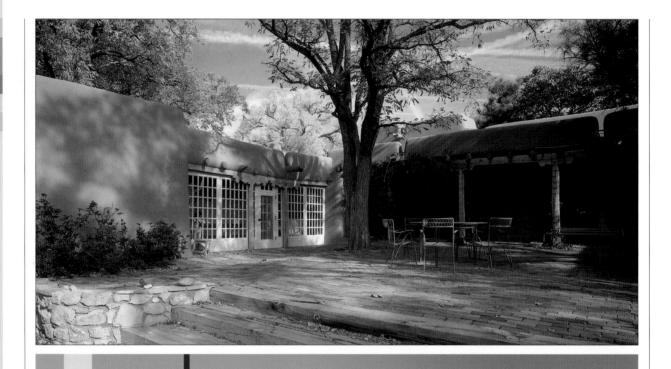

Earth, sky, trees

One of the area's classic adobe dwellings is the Trigg House, built in Spanish mission style, with an interior courtyard. In this one shot the basic elements of New Mexican colour are apparent: warm earth with splashes of bright colour from the sky and fall cottonwoods. We might also add the chiaroscuro as sunlight casts shadows on the plain expanse of adobe walls.

The Mabel Dodge house

The area attracted artists from the beginning of the 20th century, and the house of Mabel Dodge in Taos became a salon whose visitors included D.H. Lawrence – who decorated this corner fireplace in the stylistic mixture of local Hispanic and Taos Pueblo artisans.

Country market

The ranges of blue that New Mexicans choose are always interesting, even though, in most cases, a conscious sense of design does not play a part. The blues rarely stray toward violet and purple; denim dungarees are about as far from green as the range goes. The metallic colour of the old pick-up is especially fine, and a wonderful accompaniment for chilis and pumpkins being brought to market.

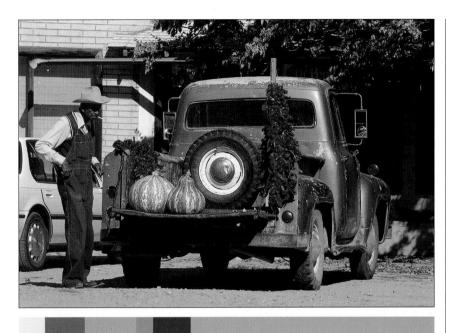

Chillis

Adobe, turquoise wood, and red chillis strung to dry could almost be seen as a signature motif - a detail that identifies the region.

Urban colours

The man-made environment of towns and cities has its own special palette in which a backdrop of desaturated, even drab, tones is set against the localized, synthetic colours of display and advertising. Just as the rock, earth, plants, and water of natural habitats create a colour signature of place, so man-made environments are distinctive. Completely urban locations (excluding the parks and gardens that are maintained precisely to soften the environment with touches of nature) have identifiable colour palettes, some of which are common to the majority of cities and towns. If you are shooting in these with an eye to exploring colour, there are some potentially interesting

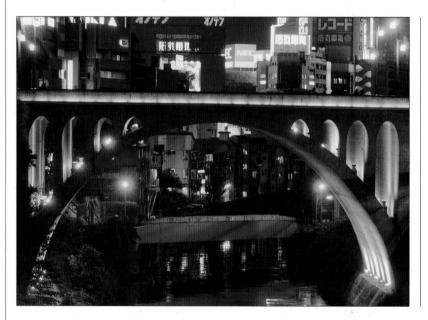

subtleties and contrasts.

The subtleties are mainly in the materials of construction, which tend to be similar in any one location for practical reasons. In modern cities, grey predominates. It is the colour of concrete, asphalt, most stone, and steel. Even glass, often used in large expanses in city centres, with little colour of its own, simply reinforces the dominant grey by reflection – especially in overcast weather. Cloudy days reduce contrast in any case, and give full play to the nuances of grey, though whether you choose to see these as

Tokyo A bridge in downtown Tokyo, near Ochanomizu, as night falls. The chiaroscuro of lights is typical, here enhanced by reflections in the water. The usual problem of photographing at night is to retain a sense of form, and here the bridge helps. drab and depressing or subtly complex – as William Egglestone has – is a matter of personal attitude.

Older cities, and city centres where older buildings have been preserved, tend to be more distinctive because of idiosyncrasies in the construction materials. The centre of the university town of Oxford, England, for example, contains many buildings - colleges and churches mainly - constructed from the local limestone, which varies in appearance from a creamy grey during the day to a soft orange in the light of a low sun. As another example, the remaining parts of many tropical former-colonial cities, such as in Singapore,

Liverpool Street

The drabness characteristic of many city environments is itself a subject for shooting in colour. Here, a bridge crossing the tracks of Liverpool Street station in London, seen from a distance with a telephoto lens through city haze, becomes a modulation of greys.

often feature whitewashed buildings and shade trees, which in the middle of the day create a particular kind of high-contrast chiaroscuro in white, black, and green.

In complete contrast to the plainness of most large-scale urban scenes are the bright colour accents of signs, shop-fronts, advertising hoardings, vehicles, and displays in general. What these all have in common is the need to attract attention through bright colours, either for warning, advertising, or amusement. As night falls in city centres, these become even more insistent. In terms of colour saturation, many urban scenes brighten at dusk.

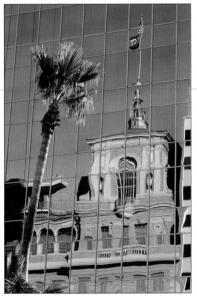

Mural

Expect the unexpected in cities. It is easy to become accustomed to the grey of concrete or the lights of the night, but this mural is certainly neither of those.

The colours of still-life

Still-life, traditionally the genre for the making rather than the taking of photographs, allows a blank canvas on which colours can be placed and arranged. **Paul Outerbridge (1896-1958),** one of the earliest still-life photographers of note to work in colour, wrote in 1940 that this genre offered the greatest possibilities 'for purely creative work in colour photography'. This is not surprising to hear for anyone who wants to exercise the kind of absolute control that painters have always had, and Outerbridge was followed by a succession of photographers of a particular

For a simple shot of a tulip, the art director quickly tore the edges of sheet of coloured paper, arranging them as a continuation of the flower's colour scheme.

personality: deliberate, measured, considered. These included Irving Penn, Hiro (Wakabayashi Yasuhiro), Henry Sandbank, and Lester Bookbinder.

Nor is it any coincidence that the work of all these bridged the creative and the commercial aesthetics. Advertising and fashion editorial in particular needed still-life in order to show products and express concepts in a tightly controlled manner. This is the antithesis of street photography, and nothing is left to chance. Absolutely everything is imported into the frame, and any shortcomings or failures are laid right at the door of the photographer (or art director). This affects the colour as much as any other component of the shot, and in this way still-life allows the ultimate expression of colour discrimination. It did also in painting, with artists such as Jean Baptiste Simeon Chardin (1699-1779) and Georges Brague (1882-1963), who used it as a vehicle for exploring truth and nature. In painting, the creation of colour from pigments was and remains an issue that spans the entire process. In most photography, the colours are normally in place before the photographer starts to work, but with still-life they can be selected with precision. In the hands of someone like Irving Penn, arguably one of the greatest of the genre's practitioners, a commissioned commercial piece can transcend the immediate job into art.

With the choice of palette completely open to the photographer, it is little surprise that there is great variety in colour still-life. Nevertheless, precision and discrimination is always obvious in any good, well-thought out shot. Many photographers are drawn to simplicity and restraint, with the accompanying demands that this makes on getting subtle hues and neutrals absolutely accurate – now completely achievable with digital post-production. Others opt for combinations of intense colours that are difficult to find in real-life.

Martini

The purity of this classic cocktail allows it no colour itself, and one way of treating it is a neutral setting. Here, however, served in an old Rajasthani fort converted into a hotel, the traditional coloured glass windows made a more unusual setting.

Shaker kitchen

Spit-roasted chicken in a reflector oven, with a tin colander and stoneware preserving jar, at a Shaker village in Kentucky. The attraction of the arrangement lies heavily in the concordance of browns and beige.

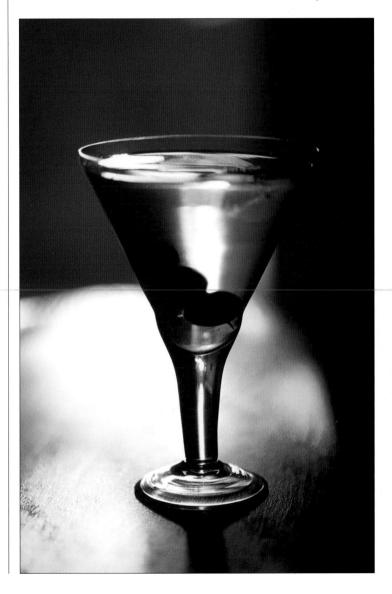

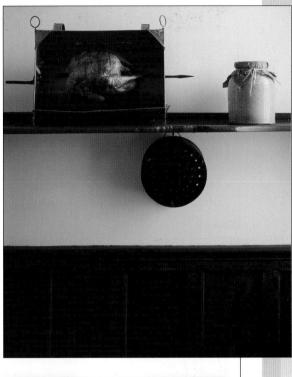

Blue bottle

The subjects were two old bottles, and the treatment was to abstract them into shape and colour, arranging them for a simple set of lines. The bottle at left was in blue glass, and to set this off, the other was filled with blue-dyed water, then aerated via a pipe to give it life.

Selective enhancement

By using the selection and colourshifting tools, it's possible to draw attention to colour relationships that might otherwise be missed. To remain realistic, this procedure should normally be applied delicately.

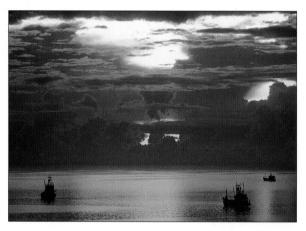

The most sensible tool to use is one that can distinguish hue, as the premise for this operation is that existing colours are being altered, not the addition of colour. There are several image-editing methods (in Photoshop, *Image > Adjustments > Replace Colour*), but the most generally useful is the HSB control. First the colour range is chosen, either by selecting a preset range such as Reds or Yellows, or by moving sliders along a bar that shows the entire range to choose one part of it. A starting point for a particular colour in a photograph is to use the selector eye-dropper on the image, and then tweak the range sliders.

With the colour, or colours, selected, the hue, saturation, and brightness can all be shifted by means of sliders, and this was the method used in both of these examples. Always exercise caution when significantly altering the values of a colour; it is easy to go too far, particularly in hue and saturation changes (brightness differences are always less intense). Colour realism is a fragile commodity in photographs.

A classic harmony

The aim here was to strengthen what already had the makings of an established harmony between yellow and violet, in a dawn view of fishing boats in the Gulf of Thailand. As shot (left), the harmony is just suggested, and the brightness of the sky in the uppermost gap in the clouds has drained the colour that persists in the lower two patches. Because there is no yellow at the top to enhance, the bright areas were first selected as a colour range, and this selection then filled in a separate layer with yellow. This was blended as an overlay with the main image. Then the lower patch of colour was adjusted to make it less orange, and the third also brought into line. Finally, the violet suffusing the clouds and sea was selected and enhanced.

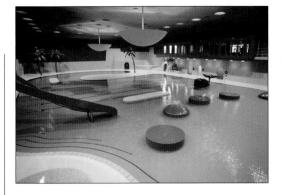

Three- and four-colour combinations

K This indoor swimming pool was deliberately designed in primary colours, but in the rather patchy lighting, these became subdued. Also, because the lighting was fluorescent, a green cast was evident. Less for correction than simply to explore the relationships, I wanted to see how the picture would look with the three primaries (red, yellow, and blue). The blue, in fact, needed no adjustment but, by using the dropper in the HSB controls, the reds and then the yellows were precisely selected and adjusted to be as pure as possible. There was still the rest of the scene to consider, most of it a murky green. In the first adjustment, these areas, mainly water, were neutralized by desaturation so that they became the ground for the interplay of bright primaries. But a second alternative also suggested itself - to enhance the green for a more complex combination of four hues.

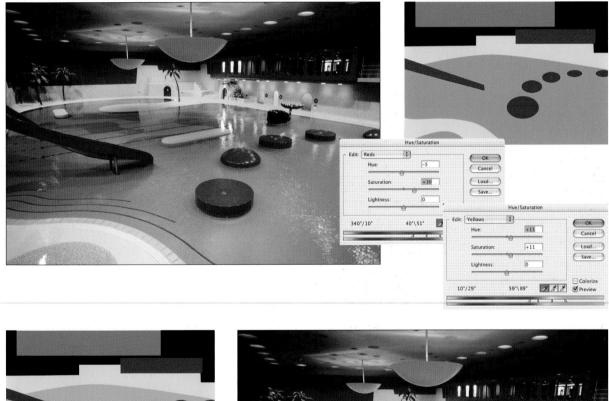

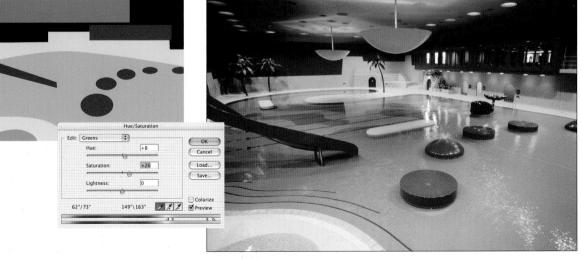

Distressed colour

There is a wide range of digital filter effects dedicated to stylizing colour, which is to say creating a nonrealistic colour character for an image by means that are usually the opposite of optimization. In the same way that new-for-old furniture can be given a patina of age by distressing its surface, colours in a photograph can be processed to give them a worn, used look. One reason for doing this is to make the image seem older, giving it the dark characteristics of, say, an Autochrome (early colour film) or a handcoloured black and white print. Another is simply to move the image away from the crisp actuality of a photograph into a realm closer to painting. For this

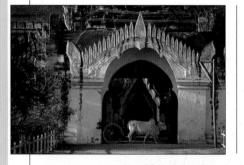

second direction there are digital techniques, mainly proprietary, for giving the appearance of brushstrokes, scumbling, and other painterly ways of applying colour. There is often an element of pastiche about this, and it will be of no interest to reportage photographers, for example. Nevertheless, the results can in their own terms be attractive, evocative and, above all, atmospheric. Distressed colour is particularly effective in prints and on textured paper, for which the new generation of desktop inkjet printers offers endless opportunities to experiment.

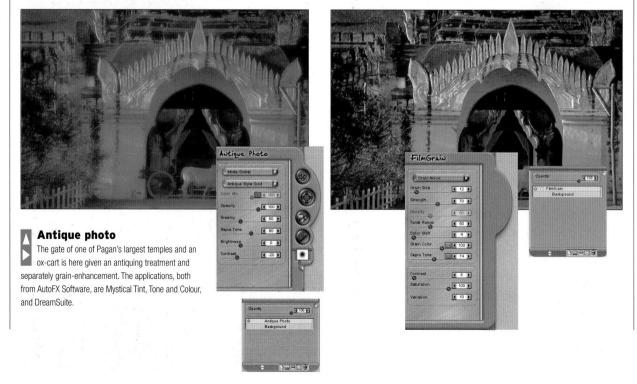

As in any form of distressing, the process involves several-to-many stages, and the imaginative use of techniques not originally designed for editing images in this way. From a software point of view this tends to be complicated rather than difficult, and the distressing of colour, as a subcategory of colour effects filters, has attracted a number of independent software companies. What most of them offer is a conveniently packaged set of procedures with an identifiable style of result. You could reproduce nearly all of these yourself using Photoshop, if you were prepared to take the time to experiment, and for occasional use on a specific image this is probably the best approach for anyone who enjoys playing with the more obscure Photoshop controls. However, price generally reflects utility in software, and these third-party plug-in filters (as most of them tend to be presented) are usually inexpensive and often part of larger filter suites. Some are even shareware – people enjoy writing this kind of program.

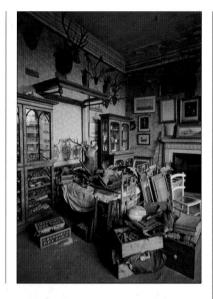

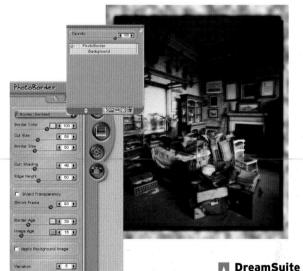

Means of distress

Most of the software aimed at distressing colours has the following features in common:

- Desaturation
- Noise and texture
- Colour cast
- · Blurring of colour

This bedroom in an old country estate in Derbyshire, England, untouched for a century, seemed a sufficiently atmospheric subject. The application used here is DreamSuite from AutoFX Software. The screenshots give an indication of the controls being applied.

Case study: unreal colour

Until now, photography has not had the technical opportunity to render colours in any way the artist pleases. Digital imaging, however, allows total manipulation of colour, as we have partly seen already. Add the techniques of selection discussed earlier to the methods of altering colour that we looked at on page 152, and you have a powerful set of tools that you can use to express the colour of an image as you like – and as radically as you like.

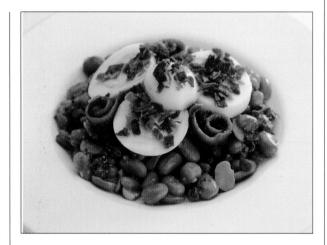

Broad bean salad

The original dish, with a bed of beans the colour that anyone would expect them to be. (British broad beans are similar to Fava beans.)

	Duplicate Layer	
olicate: Ba	ckground	ОК
As: Ba	ckground copy	Cancel
Destinatio	n	
ocument:	15809.08 Broad bean salad 🛟	
Name:	3	

Because there will inevitably be some retouching, and maybe even changes of decision, it makes sense to perform the operation on a duplicate layer.

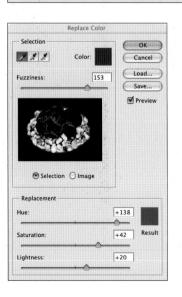

Du

D

Replace

The easy choice for altering a selected colour is the Replace Colour command. The colour sampled is the green of the beans, and the Fuzziness increased to include all of them. This also takes in some of the egg yolk, but we can deal with that later. The Hue is shifted toward blue, Saturation increased to make this more definite, and Lightness increased slightly to taste.

Stage one alteration

This is the effect of the Replace Colour procedure - on the whole as wanted, but the egg yolks have taken on a greenish tinge. I want to eliminate this, otherwise the image will seem simply to have been coloured blue. The yolks, when yellow, will make a contrasting reference colour. Because the operation has been performed on the upper duplicate layer, it is a simple matter to use the Eraser brush to take these discolourations out.

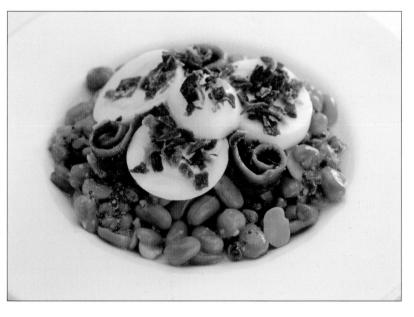

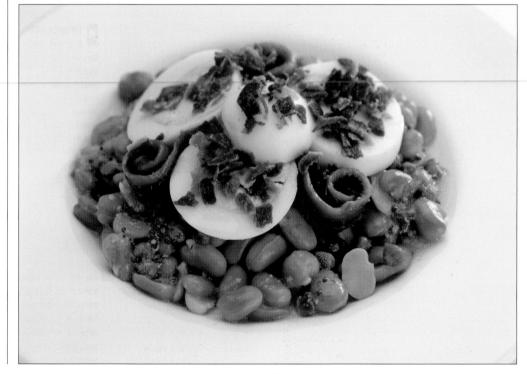

Final image With the duplicate

With the duplicate layer retouched to reveal some areas of original colour from the background image, the image is flattened. The result is a truly unappetizing dish that no-one in their right mind would want to sample. GLOSSARY

Glossary

aperture The opening behind the camera lens through which light passes on its way to the CCD.

artifact A flaw in a digital image.

backlighting The result of shooting with a light source, natural or artificial, behind the subject to create a silhouette or rimlighting effect.

bit (binary digit) The smallest data unit of binary computing, being a single 1 or 0.

bit depth The number of bits of colour data for each pixel in a digital image. A photographic-quality image needs eight bits for each of the red, green, and blue channels, making for a bit depth of 24.

bracketing A method of ensuring a correctly exposed photograph by taking three shots; one with the supposed correct exposure, one slightly underexposed, and one slightly overexposed.

brightness The level of light intensity. One of the three dimensions of colour in the HSB colour system. See also Hue and Saturation

byte Eight bits. The basic unit of desktop computing. 1,024 bytes equals one kilobyte (KB), 1,024 kilobytes equals one megabyte (MB), and 1,024 megabytes equals one gigabyte (GB).

calibration The process of adjusting a device, such as a monitor, so that it works consistently with others, such as scanners or printers.

CCD (Charge-Coupled Device) A tiny photocell used to convert light into an electronic signal. Used in densely packed arrays, CCDs are the recording medium in most digital cameras.

channel Part of an image as stored in the computer; similar to a layer. Commonly, a colour image will have a channel allocated to each primary colour (e.g. RGB) and sometimes one or more for a mask or other effects.

CMOS (Complementary Metal-Oxide

Semiconductor) An alternative sensor technology to the CCD, CMOS chips are used in ultra-high-resolution cameras from Canon and Kodak.

colour temperature A way of describing the colour differences in light, measured in Kelvins and using a scale that ranges from dull red (1,900K), through orange, to yellow, white, and blue (10,000K).

compression Technique for reducing the amount of space that a file occupies, by removing redundant data.

contrast The range of tones across an image, from bright highlights to dark shadows.

cropping The process of removing unwanted areas of an image, leaving behind the most significant elements.

depth of field The distance in front of and behind the point of focus in a photograph, in which the scene remains in acceptable sharp focus.

diffusion The scattering of light by a material, resulting in a softening of the light and of any shadows cast. Diffusion occurs in nature through mist and cloud cover, and can also be simulated using diffusion sheets and soft-boxes.

edge lighting Light that hits the subject from behind and slightly to one side, creating flare or a bright "rim lighting" effect around the edges of the subject.

feathering In image-editing, the fading of the edge of an image or selection.

file format The method of writing and storing information (such as an image) in digital form. Formats commonly used for photographs include TIFF, BMP, and JPEG.

fill-in flash A technique that uses the on-camera flash or an external flash in combination with natural or ambient light to reveal detail in the scene and reduce shadows. **filter** (1) A thin sheet of transparent material placed over a camera lens or light source to modify the quality or colour of the light passing through. (2) A feature in an image-editing application that alters or transforms selected pixels for some kind of visual effect.

focal length The distance between the optical centre of a lens and its point of focus when the lens is focused on infinity.

focal range The range over which a camera or lens is able to focus on a subject (for example, 0.5m to Infinity).

focus The optical state where the light rays converge on the film or CCD to produce the sharpest possible image.

fringe In image-editing, an unwanted border effect to a selection, where the pixels combine some of the colours inside the selection and some from the background.

frontal light Light that hits the subject from behind the camera, creating bright, high-contrast images, but with flat shadows and less relief.

f-stop The calibration of the aperture size of a photographic lens.

gradation The smooth blending of one tone or colour into another, or from transparent to coloured in a tint. A graduated lens filter, for instance, might be dark on one side, fading to clear on the other.

grayscale An image made up of a sequential series of 256 grey tones, covering the entire gamut between black and white.

haze The scattering of light by particles in the atmosphere, usually caused by fine dust, high humidity, or pollution. Haze makes a scene paler with distance, and softens the hard edges of sunlight.

histogram A map of the distribution of tones in an image, arranged as a graph.

GLOSSARY

The horizontal axis goes from the darkest tones to the lightest, while the vertical axis shows the number of pixels in that range.

hot-shoe An accessory fitting found on most digital and film SLR cameras and some high-end compact models, normally used to control an external flash unit.

HSB (Hue, Saturation, Brightness) The three dimensions of colour, and the standard colour model used to adjust colour in many image-editing applications.

hue The pure colour defined by position on the colour spectrum; what is generally meant by "colour" in lay terms.

ISO An international standard rating for film speed, with the film getting faster as the rating increases. ISO 400 film is twice as fast as ISO 200, and will produce a correct exposure with less light and/or a shorter exposure. However, higher-speed film tends to produce more grain in the exposure, too.

lasso In image-editing, a tool used to draw an outline around an area of an image for the purposes of selection.

layer In image-editing, one level of an image file, separate from the rest, allowing different elements to be edited separately.

light tent A tent-like structure, varying in size and material, used to diffuse light over a wider area for close-up shots.

luminosity The brightness of a colour, independent of the hue or saturation.

macro A mode offered by some lenses and cameras that enables the lens or camera to focus in extreme close-up.

mask In image-editing, a grayscale template that hides part of an image. One of the most important tools in editing an image, it is used to limit changes to a particular area or protect part of an image from alteration.

megapixel A rating of resolution for a digital camera, directly related to the number of pixels forming or output by

the CMOS or CCD sensor. The higher the megapixel rating, the higher the resolution of images created by the camera.

midtone The parts of an image that are approximately average in tone, falling midway between the highlights and shadows.

monobloc An all-in-one flash unit with the controls and power supply built-in. Monoblocs can be synchronized together to create more elaborate lighting setups.

noise Random pattern of small spots on a digital image that are generally unwanted, caused by nonimage-forming electrical signals.

pixel (PICture ELement) The smallest units of a digital image, pixels are the square screen dots that make up a bitmapped picture. Each pixel carries a specific tone and colour.

plug-in In image-editing, software produced by a third party and intended to supplement a program's features or performance.

ppi (pixels-per-inch) A measure of resolution for a bitmapped image.

reflector An object or material used to bounce available light or studio lighting onto the subject, often softening and dispersing the light for a more attractive end result.

resampling Changing the resolution of an image either by removing pixels (lowering resolution) or adding them by interpolation (increasing resolution).

resolution The level of detail in a digital image, measured in pixels (e.g. 1,024 by 768 pixels), lines-per-inch (on a monitor) or dots-per-inch (in a half-tone image, e.g. 1,200 dpi).

RGB (Red, Green, Blue) The primary colours of the additive model, used in monitors and image-editing programs.

saturation The purity of a colour, going from the lightest tint to the deepest, most saturated tone.

selection In image-editing, a part of an

on-screen image that is chosen and defined by a border in preparation for manipulation or movement.

shutter The device inside a conventional camera that controls the length of time during which the film is exposed to light. Many digital cameras don't have a shutter, but the term is still used as shorthand to describe the electronic mechanism that controls the length of exposure for the CCD.

shutter speed The time the shutter (or electronic switch) leaves the CCD or film open to light during an exposure.

SLR (Single Lens Reflex) A camera that transmits the same image via a mirror to the film and viewfinder, ensuring that you get exactly what you see in terms of focus and composition.

snoot A tapered barrel attached to a lamp in order to concentrate the light emitted into a spotlight.

soft-box A studio lighting accessory consisting of a flexible box that attaches to a light source at one end and has an adjustable diffusion screen at the other, softening the light and any shadows castby the subject.

spot meter A specialized light meter, or function of the camera light meter, that takes an exposure reading for a precisearea of a scene.

telephoto A photographic lens with a long focal length that enables distant objects to be enlarged. The drawbacks include a limited depth of field and angle of view.

TTL (Through The Lens) Describes metering systems that use the light passing through the lens to evaluate exposure details.

white balance A digital camera control used to balance exposure and colour settings for artificial lighting types.

zoom A camera lens with an adjustable focal length, giving, in effect, a range of lenses in one. Drawbacks include a smaller maximum aperture and increased distortion over a prime lens (one with a fixed focal length).

Index

A

absolute colorimetric 63 absorption 30-1, 41, 50, 115 accents 101, 110-11 accuracy 72-3 Adobe RGB 64, 70 advertising 146-8 Albers, Josef 89, 92 angle of view 124-5 Apelles 19 Apple RGB 64 Aristotle 16, 19 Art Deco 143 associations 18, 87-9, 114 Atkinson, Bill 85

В

backgrounds 52, 110-11, 115 Bacon, Francis 135 balance 57, 73, 79, 89, 96, 98-9, 101, 104, 108-10, 131 Bauhaus 14, 19, 88 Berry, Ian 133 Bezold, Wilhelm von 92 black 52-3, 66, 70, 78-9, 108 black light 49 Blanc, Charles 13 Der Blaue Reiter 41 blue 40-3, 102-3, 115, 139 blur 99 Bookbinder, Lester 148 Boyle, Robert 19 bracketing 23, 54, 80 Braque, Georges 148 brightness 13, 22-3, 44, 65-6, 79-80, 82-3, 88, 96-9, 103, 110, 117, 131, 139, 150 broken-spectrum lighting 28-9.38 brown 120-1

С

calibration 61, 63, 66-7 camera profiling 61, 63, 70-1, 73, 84

candles 38-9, 50, 103 Chardin, Jean Baptiste 148 Chevreul, Michel 90, 98 chroma see saturation chromatic grey 57-9, 116 Clark, Kenneth 99 clipping 55, 70, 78-9 CMYK 63-5 colorimeters 67 colour casts 53, 57, 79, 111, 131, 153 circle 9, 12-14, 20, 25, 55, 90, 96, 99, 108-9, 114-15 control 69, 72-3, 131, 136, 138, 148 cube 17 management 62-3, 66, 70, 82, 84 mode 63 models 12-15, 65, 112 mosaic 70 space 64-5 tree 14 triangle 12-13 values 69-70, 79-80, 87, 96, 98-9, 150 Colour Management System (CMS) 63 Commission Internationale d'Eclairage (CIE) 15, 65, 75 complementaries 14, 21, 65, 87, 90-1, 96-8, 104, 108, 111-12, 114 composition 110, 135, 139 Constable, John 13 contrast 52, 67-8, 70, 79-81, 88-9, 95, 98, 104, 108, 111, 113-15, 136-7, 147 Cook, Chris 35 cool colours 114-15 Cultural Revolution 34 curves 78, 81

D

Da Vinci, Leonardo 17, 103 Delacroix, Eugène 12, 111 Democritus 16, 19 depth 31, 115 device-independent colour 65 discord 87, 89-90, 96, 112-13, 128 distressed colour 152-3 Dodge, Mabel 144 dusk/dawn 49, 114, 139, 147 dye-transfer process 131

Е

Eggleston, William 136, 146 enhancement 150-1 equilibrium 89, 99 exposure 56, 68-70, 80-1, 83 expressionists 102

F

faces 123 Field, George 13 file formats 61, 68, 80-1 filters 27, 32, 57, 152-3 flames 38-9, 50, 114 flash 31, 135 flesh tones 70, 73-4, 122-3 flicker effects 94 fluorescent light 27-9, 68, 114, 151 four-colour combinations 151 framing 135

G

Gage, John 16, 96, 138 gamma 66-7 gamut 48, 63-4, 78 Gauguin, Paul 10 Goethe, J.W. von 96, 98-9 gold 39, 46, 51, 125 Gombrich, Ernst 94 gradated focus 99 gradients 122-3 green 44-7, 100-1, 113, 115, 151 GretagMacbeth ColorChecker 70-1, 76 grey 56-9, 70, 79, 91, 96, 108-9, 116, 146 grey card 56-7, 68, 70-1, 73 Groover, Jan 135, 139 groups of photographs 128

н

Haas, Ernst 135-8 Hals, Frans 117 hand-held meters 56 harmony 87, 89-90, 96-105, 109-10, 112, 114, 128, 150 High Dynamic Range (HDR) 81 Hiro 148 Hokusai 53 HSB 65, 75, 82, 150-1 hue 13, 17, 57-8, 64, 68, 75, 79-80, 82-3, 88, 96, 99-100, 104, 108, 139, 150

I

iCorrect 65, 75, 79, 122 inCamera 70 inks 48, 65, 85 intensity 136-7 International Colour Consortium (ICC) 70, 85 interrupted colour 95 iridescence 124-7 Itten, Johannes 14, 19, 88

J

JPEG format 68, 81 juxtaposition 139

Κ

Kandinsky, Wassily 19, 112-13 kelvins 26-7 Kodachrome 131, 136

L

L*a*b* 15, 63, 65 Lawrence, D.H. 144 lens flare 38 light 24-5, 28-31, 38, 52, 68, 70, 73, 80, 84, 98, 102-3, 108, 111, 114, 124, 138-40, 151

INDEX

linear scale 13 local colour 111

Μ

Macke, August 41, 102 Magnum 133 Maisel, Jav 136 Malevich Kasimir 55 Manet, Edouard 53 Matisse, Henri 53, 135 Maxwell, James 10 memory colours 74-5, 122 metallics 87, 124-7, 145 metamerism 31 Meverowitz, Joel 135, 139 mid-grey 56, 66 Mondrian, Piet 18-19 monitors 14, 17, 19, 48, 53, 61 63.66-7 Montiosieu. Louis de 19 Morley, Bob 132 multi-colour combinations 106-9 Munsell, Albert 13-14, 70 muted colours 116-21

Ν

National Geographic 100, 136 nature 44-7, 57, 100, 148 neighboring colours 99, 115 neutrals 55, 57-8, 66, 68, 70, 73-5, 79, 91, 96, 108-9, 111, 117, 151 New Colour 136, 139 Newton, Isaac 6, 9, 12, 14, 24

0

Op Art 94 OptiCal 67 optical effects 90-5, 98, 100, 112, 124 optimisation 74, 79, 81, 152 orange 50-1, 102-3, 114 Oudry, Jean Baptiste 54 Outerbridge, Paul 148 overexposure 52, 55-6, 80

Ρ

painters' primaries 17-19 paper 17, 53, 65, 80, 85, 152

Parr. Martin 113, 135 pastels 87, 107-8, 117 Penn, Irving 148 personal colours 76-7 Photo-Realism 99 PhotoMatix 81 photopic system 92 Photoshop 9, 15, 46, 50, 52, 61, 63-5, 68-71, 75, 77-8, 81, 87, 91, 109, 122, 132, 135, 137, 150, 153-5 physical response 6, 11, 18 physiological response 6, 9, 11, 92, 99, 110 PicotColor 70 plants 44, 87, 146 Plinv the Elder 19 plua-ins 70, 153 Porter, Eliot 135 pre-set 68 primary hues 14-19, 58, 87, 96, 98, 103, 108-9, 116, 151 printer profiling 61, 63, 84-5 prints 14, 53, 56, 64, 128, 152 projects 19, 77 proportion 97, 99, 101, 103-4, 108, 110 psychological response 6, 11. 18, 29, 46, 82, 87, 89-90, 96 99 Purkinie shift 92

Ρ

Raw format 61, 68, 80-1 red 32-5, 100-1, 113

R

Reference Colour Space 63 reflected light 13-14, 17, 19, 24, 30-1, 39, 46 reflections 41, 124-5 refraction 30, 124 relationships 88-9, 110, 128, 132, 150 relative colorimetric 63 Rembrandt 117 Renaissance 19 render intent 63 restrained colour 138-9 retina 6, 10-11, 87 RGB 9, 17-18, 46, 53, 58, 63-4, 69, 79 richness 136-7, 139

Riley, Bridget 94 Risex, Nicoletto 19 Rowell, Galen 136

S

sampling 65 Sandbank, Henry 148 saturation 13, 20-1, 57-9, 63, 75, 79-80, 82-3, 88, 98-9, 109, 136-7, 139, 147, 150-1 scotopic system 25, 92 secondary hues 12-14, 18-19, 58, 87, 98, 103, 108-9, 116 sensation 88, 114-15, 136 sequential images 128-9 shadows 41, 52-3, 70, 79-81, 103, 114, 117, 135 shape 19, 88, 98 shooting 70, 84 Shore, Stephen 136, 139 silhouettes 52, 80, 111, 139 simultaneous contrast 89-93, 98 skin tones 70, 73-4, 122-3 sky 41-2, 68, 70, 73, 75, 94, 103, 114, 150 SmartColor 79 software 61-3, 65, 67-71, 75, 79. 81-2. 85. 122. 153 spatial contrast 88 spectrophotometers 67, 84-5 spectrum 6, 12, 24-5, 28-9, 41, 59, 115 spot colour 111 Spyder 66-7 sRGB 64 still-life photography 54, 148-9 style 134-7, 142, 152 subjectivity 82-3, 89, 112, 140 subjects 132-3 successive contrast 89-91, 98 Suprematists 34 surface composition 30-1 Szarkowski, John 132-3,

136, 138

T targets 70, 73, 75, 79, 84-5

temperature 6, 26-7, 34, 38, 41, 50, 66, 73, 88, 102-3, 114-15 testing 70, 85 Theophrastus 16 theory 10-11, 24, 27, 89-90, 96, 116 three-colour combinations 151 three-way colour 109 TIFF format 68, 81 tone mapping 81 transmitted light 14, 17, 19, 24, 30-1 tristimulus response 10 tungsten 38-9, 50, 103, 114

tungsten 38-9, 50, 103, 114 Turner, Peter 136

U

underexposure 55-6, 136 unreal colour 154-5 urban colour 146-7

V

Van Gogh, Vincent 6, 113, 135 vanishing boundaries 94 vapour-discharge lamps 27-9 Vasarely, T.K. 94 vegetation 46, 70, 74, 140 vibration 32, 94, 100, 102 viewing conditions 66 violet 48-9, 104-5, 150 visual cortex 87, 90, 108

W

warm colours 114-15 water 41-2, 115, 146, 151 wavelength 6, 10-12, 24-5, 28, 31, 41, 44, 49, 115 Webb, Alex 135 white 54-5, 66, 70, 78-9, 108 white balance 9, 24, 26, 28-30, 39, 56, 61, 68, 73 Windows 66-7 Wratten filters 27, 32

Y, Z

Yasuhiro, Wakabayashi 148 yellow 36-9, 104-5, 113, 150 159

Acknowledgements

The Author would like to thank the following for all their assistance in the creation of this title: Filmplus Ltd, Nikon UK, REALVIZ, and nikMultimedia.

Useful Addresses

Adobe (Photoshop, Illustrator) www.adobe.com

Aqfa www.aqfa.com

Alien Skin (Photoshop Plug-ins) www.alienskin.com

Apple Computer www.apple.com

Canon www.canon.com

Corel (Photo-Paint, Paint Shop Pro) www.corel.com

Digital camera information www.dpreview.com

Epson www.epson.com

Extensis www.extensis.com

Formac www.formac.com Fractal www.fractal.com

Fujifilm www.fujifilm.com

Hasselblad www.hasselblad.se

Hewlett-Packard www.hp.com

lomega www.iomega.com

Kingston (memory) www.kingston.com

Kodak www.kodak.com

Konika Minolta www.konicaminolta.com

LaCie www.lacie.com

Lexmark www.lexmark.com

Linotype www.linotype.org

Lyson (paper and inks) www.lyson.com Macromedia (Director) www.macromedia.com Microsoft www.microsoft.com Nikon www.nikon.com Nixvue www.nixvue.com Olympus www.olympusamerica.com Paint Shop Pro www.corel.com Pantone www.pantone.com Photographic information site www.ephotozine.com Photomatix www.hdrsoft.com Photoshop tutorial sites www.planetphotoshop.com www.ultimate-photoshop.com Qimage Pro www.ddisoftware.com/gimage/ Ricoh www.ricoh.com Samsung www.samsung.com Sanyo www.sanyo.co.jp

Sony www.sony.com

Symantec www.symantec.com

Umax www.umax.com

Wacom (graphics tablets) www.wacom.com